BIRGIT HÜTTEMANN-HOLZ

How to Create Encaustic Art

A GUIDE TO PAINTING WITH WAX

Schiffer Publishing Ltd®

4880 Lower Valley Road • Atglen, PA 19310

Other Schiffer Books on Related Subjects:

Encaustic Art in the Twenty-First Century, Anne Lee & E. Ashley Rooney, Foreword by Kim Bernard, Afterword by Ellen Koment, ISBN 978-0-7643-5023-8

Pigments of Your Imagination: Creating with Alcohol Inks, 2nd Ed., Cathy Taylor, ISBN 978-0-7643-5133-4

Fire and Light: A Method of Painting for Artists Who Love Color, Julie H. Hanson, ISBN 978-0-7643-5217-1

Originally published as *Enkaustik* by Christophorus Verlag GmbH & Co. KG, Freiburg © 2015 Christophorus Verlag GmbH & Co. KG Translated from the German by Omicron Language Solutions, LLC

Library of Congress Control Number: 2017935518

Cover design by Brenda McCallum
Type set in Helvetica Neue LT Pro

Photo credits: p. 4: © Jack O. Summers; pp. 7, 98, 99: © Colt Weatherstone; p. 9: © Bridgeman Images; pp. 10, 11: akg-images, Jasper Johns, © VG Bild-Kunst, Bonn 2015; p. 21 top: © Darin Seim; pp. 43, 44, 95: © Jana Hartmann; pp. 108, 109: © Robin Denevan; pp. 110, 111: © Betsy Eby; pp. 112, 113: © E.G. Schempf; pp. 114, 115: © Alexandre Masino; p. 116: © Robin Samiljan; p. 117: © Jantje Janssen; p. 118, 119: © Paula Roland; pp. 120, 121: © Shawn Sagolili; pp. 122, 123: © Yasemin Skrezka; pp. 124, 125: © Georg Weise; pp. 17, 20, 31 right, 37, 39: © Frank Schuppelius; all remaining photo credits: © Philipp Hüttemann.

The author thanks Art Select GmbH & Co. KG for their kind support.

ISBN: 978-0-7643-5416-8
Printed in China

Published by Schiffer Publishing, Ltd.
4880 Lower Valley Road
Atglen, PA 19310
Phone: (610) 593-1777; Fax: (610) 593-2002
E-mail: Info@schifferbooks.com
Web: www.schifferbooks.com

For our complete selection of fine books on this and related subjects, please visit our website at www.schifferbooks.com. You may also write for a free catalog.

Schiffer Publishing's titles are available at special discounts for bulk purchases for sales promotions or premiums. Special editions, including personalized covers, corporate imprints, and excerpts, can be created in large quantities for special needs. For more information, contact the publisher.

We are always looking for people to write books on new and related subjects. If you have an idea for a book, please contact us at proposals@schifferbooks.com.

Contents

Foreword . 6

A Brief Historical Overview 8

Special Instructions
for Working with Wax 12
General Precautions . 12
Special Precautions . 12

Materials and Supplies 16
Materials . 16
Supplies . 21

Painting Substrates
and Painting Grounds 28
Painting Substrates . 28
Painting Grounds . 31

Encaustic Medium and Paints 34
Encaustic Medium . 34
Encaustic Paints . 36

Starting Out . 42
Preparing the Ground . 42
Fusing Technique . 44
First Paint Application . 45
Mixing the Paints . 46
Transparency Compared to Opacity 47
Cleaning Brushes and Palette 48

Smooth Surfaces . 52
Indirect Fusing Method with a Hot Air Gun 52
Direct Fusing Method with a
 Painting Iron or Clothes Iron 53

Textured Surfaces . 56
Spattering . 56
Using the Palette Knife . 58
Pouring . 60

Accretion . 62
Relief Imprint . 64
Subtractive and Additive Techniques 70
Sgraffito: Scraping Out Technique 74
Masking Technique for Lines and Shapes 76
Stencils . 78

Collages . 80
Paper . 80
Organic Materials . 82
Metal Leaf and Gilding with Transfer Gold 84

Image Transfer Techniques 86
Photocopies . 86
Carbon Paper . 88
Charcoal and Graphite Drawings 89

Mixed-Media Techniques 90
Oil Sticks, Pigment Sticks, Oil Paints 90
Oil Pastels . 92

Monotype in Encaustic 94
Introduction . 94
Print Imaging . 96

Displaying and Care 100
Wax Drops . 100
Wax Edges, Borders, and Frames 101
Polishing the Painting Surface 102
Storing and Transporting
 Encaustic Paintings . 103

Gallery:
Contemporary Encaustic
in Europe and North America 106

Glossary . 126

Afterword . 128

Foreword

When I encountered the technique of encaustic painting for the first time, I had no idea what to expect. A painter friend persuaded me to attend a course called "Introduction to Encaustic." It was winter in Detroit, which was like a little ice age for me as a German, so I thought, why not shorten the time and learn something new? What I had not expected was that just the first three hours of my introduction to encaustic painting would change my entire artistic creative work.

Maybe it was the scent of honey, which was released by the melting wax, or the seemingly adventurous way of painting with fire, by using a propane torch, or perhaps the intensity and brilliance of the colors—for me, there was no turning back.

Since then, I have painted and worked only in encaustic. After the course, I rolled myself up into a ball, painted incessantly, devoted myself to reading the standard work by Joanne Mattera called *The Art of Encaustic Painting,* continued to search for more to read, and developed my own approach to painting in wax. Today,

knowledge about and application of encaustic is simply exploding in the United States. More and more artists are discovering this medium for themselves, enhancing it and developing it further. In the US, museum exhibitions are being dedicated to this ancient medium and its versatile, contemporary application! Thus my wish grew, to introduce a book on the essentials and an overview of contemporary encaustic art. I am very grateful that I was able to find a publisher for this book.

I am deeply grateful also to the many international artists whose support I have experienced and who spontaneously agreed to let me publish their paintings in this book. I know that this book illustrates only a small fraction of the artistic possibilities offered by encaustic.

My selection of contemporary works to present here leaves out many equally valuable works and artists. My hope is that this book will provide an impetus for you to gain more experience with encaustic—be it in exhibitions, through books and articles, or through your own practical work with wax.

Birgit Hüttemann-Holz

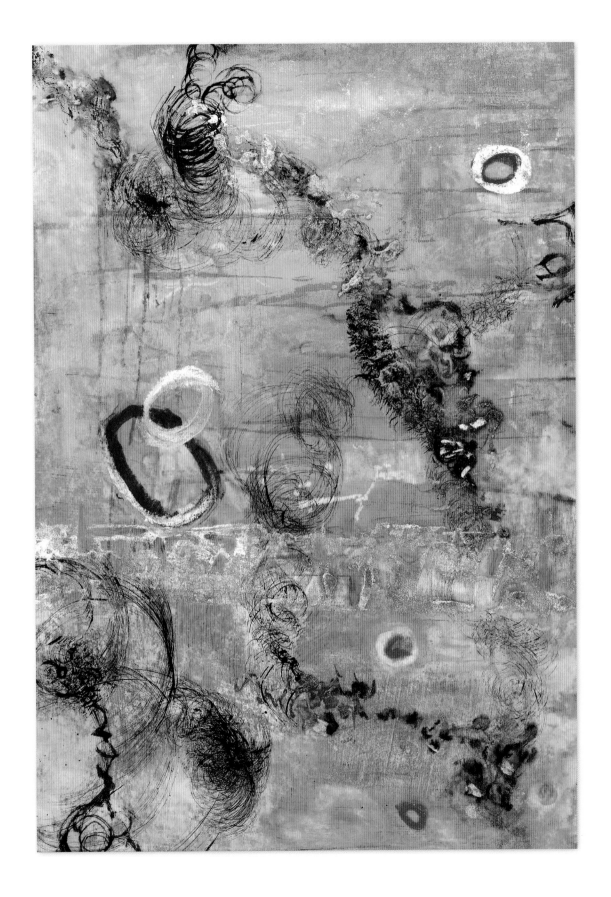

A Brief Historical Overview

Encaustic painting had its first flowering in Greco-Roman antiquity. Initially, beeswax and resin were used in ship-building, to absorb into and seal the hulls and seams. Then pigments were mixed into the wax, and people began to use a brush to decoratively paint and add designs to the ships. In the eighth century BCE, Homer told of painted warships that sailed to Troy. In the fourth century BCE, Greek artists began to apply wax painting to the design of clay objects and marble statues, as well as using it in two-dimensional wood panel painting. There are also traditions for other techniques, such as the application of a cold paste wax that had to be burned in, as well as burning designs into wood and ivory with a glowing stylus, a cestrum. Colored wax was then burned into the lines and patterns formed. Because the burning in / fusing of the wax or the use of hot, liquid wax was common to all techniques, they were collected under the term "encaustic." *Encaustic* comes from the Greek word *Enkausis* (to burn in). The most famous products of ancient encaustic painting are the Fayum portraits (mummy portraits). During the excavation of an ancient Egyptian necropolis (city of the dead) in Hawara, at the entrance of the Fayum basin, in 1888, the British archaeologist Sir W. M. Flinders Petrie found a burial site from the Greco-Roman period, which contained a variety of mummy portraits.

Greek artists, then following Alexander the Great, had settled in Hawara and practiced their craft there. Thus it was that for a certain period, Greek portraiture developed into an integral part of Egyptian funeral ritual. The portraits of the deceased were painted on wood panels that were placed on the mummy at the height of the face and were wrapped around using cloths and fastened on. They come from the classic and highly respected tradition of wood panel painting, which was used to represent the person in the Greco-Roman tradition. A head or bust representation, in a frontal view, was most frequently selected, with the head rotated slightly. The mummy portraits were either painted in encaustic or, later, in tempera. The encaustic paintings were particularly distinguished by their luminosity and their special, almost impressionistic brushwork, which was caused by the fast-cooling wax. Approximately 900 mummy portraits have been excavated worldwide and many can be seen today in museums. The 2,000-year-old wax pictures are in an astonishing, almost immaculate condition, with the colors still very intense, fresh, and of amazing brilliance. Some offshoots of encaustic painting lasted up to the time of Byzantine icon painting. In the seventh century BCE, however, encaustic was replaced by the less costly technique of tempera painting and encaustic became forgotten, a lost art. Wax was still used for various purposes in the Middle Ages. In 1505, Leonardo da Vinci attempted a wall painting using al secco, a technique related to encaustic, to apply paint on stucco. But the colors in the upper section ran when he was affixing them with hot air, and he considered the project a failure. In the nineteenth century, fresco painters tried to use the technique of encaustic as a medium to deal with the problem of dampness in wall paintings, also without success.

The invention of the propane torch again ignited interest in encaustic painting. But the breakthrough in encaustic technique first came with the use of electrical

8

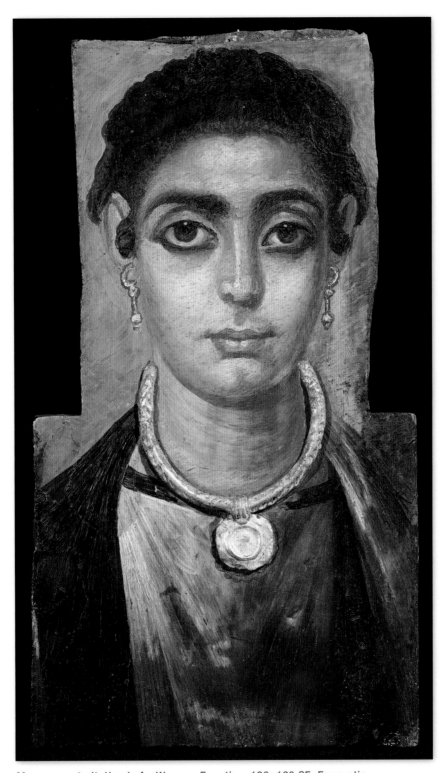

Mummy portrait: Head of a Woman, Egyptian, 130–160 CE. Encaustic with gilded stucco on wood. Detroit Institute of Arts, gift of Julius H. Haass. Bridgeman Images.

equipment, which simplified melting the wax. During the 1920s, Diego Rivera painted walls in Mexico City with wax, and in the 1940s, Karl Zerbe experimented with encaustic and developed a formula (eight parts beeswax, one part damar, and one part Venetian turpentine) that is still used, slightly modified, even today. In 1949, Frances Pratt and Becca Fizel published the book *Encaustic Materials and Methods,* which contained formulas, techniques, and historical references. The artists of the time experimented and each developed their own techniques with wax, including Jackson Pollock, David Aronson, Rifka Angel, and Arthur Garfield Dove. However, it was Jasper Johns who restored the ancient medium to current popularity. In his pop art pictures, he used pigmented wax for

his collages and this made it possible for him to use his characteristic impasto technique. Each brush stroke and drop was considered legitimate, and not touched again. The result was paintings that were more haptic. In order to fuse the paint, he first used an electric lamp, and then later a hot plate, which he fastened to a cane, to move it over the picture surface. He pigmented the wax oil paints; only later did he move on to pigments. Since then, many artists have rediscovered the technique of encaustic. Especially in the US, there are many artists who paint and work exclusively in this versatile medium. The unique intensity of the colors, the possibilities for transparency, for surface design, and for collage, as well as the excellent conservation properties, are all features of encaustic. As

Jasper Johns (born 1930), *Tango,* 1955. Encaustic and collage on canvas with music box, 42.99" × 55" (109.2 × 139.7 cm). Ludwig Collection.

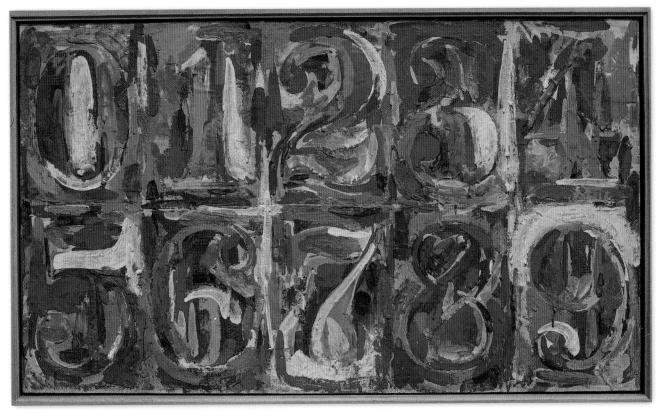

Jasper Johns (born 1930), *Zero to Nine / 0 to 9,* 1958–1959. Encaustic and collage on canvas, 21.18" × 35" (53.8 × 88.9 cm). Ludwig Collection.

a method of painting, encaustic offers a wide range of possibilities for design and application, which can't be achieved in traditional oil painting, for example.

In the last ten years especially, the popularity of encaustic painting has increased enormously. Every year, an international encaustic conference is held under the sponsorship of Joanne Mattera: the International Encaustic Conference in Provincetown, Massachusetts. The conference features exhibitions, workshops, and a lively exchange among artists, and new products are introduced.

But it's the intensive engagement of artists with encaustic, and their professional work, that broadens the boundaries of this painting technique and continues to create new areas of application.

Special Instructions for Working with Wax

If you're working in encaustic, general and special precautions apply.

You need power for your work, and it's helpful to have several outlets available at your workplace. It is also important that your workplace is well ventilated. For safety, you should have a fire extinguisher handy.

General Precautions

Keep your workplace clean and organized. Change your clothes! Work clothes do not belong in your normal home environment. And wash your hands thoroughly!

Use latex gloves or barrier cream, a protective cream which provides a protective layer for the skin and can be washed off easily and quickly, without your having to handle solvents.

Do not eat in your studio while working, for example, when you're handling oil paints or pigments.

Barrier creams protect your hands.

Special Precautions

Wax

Use a thermostat or a temperature regulator, and always check the temperature of your wax medium! The wax medium should not be heated any higher than 248° F (120° C).

Important note: If it starts smoking, that means danger. The wax medium is too hot!

If the wax is heated above 249.8° F (121° C), it begins to decompose and develops dangerous gases, vapors, or smoke, which contain acrolein and formaldehyde, among other substances. The higher the temperature, the greater the release of these substances, and this may lead to respiratory irritations, allergies, and lung diseases.

Take care to ensure you have adequate ventilation by using exhaust hoods and a good air supply intake, as well as a professionally equipped studio. Do not lean over the hot plates on which your melt the wax.

> **If the wax ignites, use the fire extinguisher, not water! Water can cause a grease fire explosion with high jets of flame.**

Have a fire extinguisher ready and at hand. The flash point of wax is 509° F (265° C) and the self-ignition temperature is 563° F (295° C).

Condensed wax—a cloud of small wax particles which form above the heated wax—can catch fire from a spark (from a propane torch).

For serious burns, that is, more than from a few drops of wax, go to the nearest cold water tap immediately, or even better, make an ice water bath and cool the skin to prevent blistering.

Do not pull the wax off immediately—it could take the skin along with it. Instead, wait until the wax has cooled in the cold water and then remove it. For smaller burns, you can use a burn gel or aloe vera. For serious burns, you should consult a doctor.

Hot Plates, Hot Air Guns, and Propane Torches

To start with: follow the instructions for the electrical appliances you're using!

Use hot plates or warming plates that have a built-in thermostat to optimally control the temperature. Be careful with multi-outlets. The electrical appliances use a lot of power, so be sure there is a surge protector built into your multi-outlet.

Be sure to turn off the appliance when you leave the studio—I always prefer to pull all the plugs out of the socket.

Hot air gun fixtures are made of metal and become very hot after being used for a long time! Therefore, handle them with care.

Put the gun someplace where it will not get in your way. The best method is to cut out a hole in a piece of particle board, where you can mount the heat gun. If you use a propane torch to fuse the encaustic paint, you should clear all inflammable materials out of the way.

> **Do not set a still-burning propane torch on the table "to quickly do something else"—turn off the gas.**

Do not use solvents when working with a propane torch. All solvents are flammable!

Pigments

It is safest to work with encaustic color cakes (such as those from R&F Handmade Paints) or to pigment the wax with oil paints. If you are working with powdered pigments, you should wear a half mask that protects against fine dust particles, to prevent any possible inhalation of pigment particles. Any pigment particles floating upward, particularly of Indian yellow, are dangerous.

Avoid using pigments made of cadmium, chromium, cobalt, mercury, lead, or barium base. Do not use any white lead, baryte yellow, chrome orange, mineral fire red, or zinc chromate. Definitely pay attention to the list of ingredients and any manufacturer's instructions about your materials, and treat them accordingly!

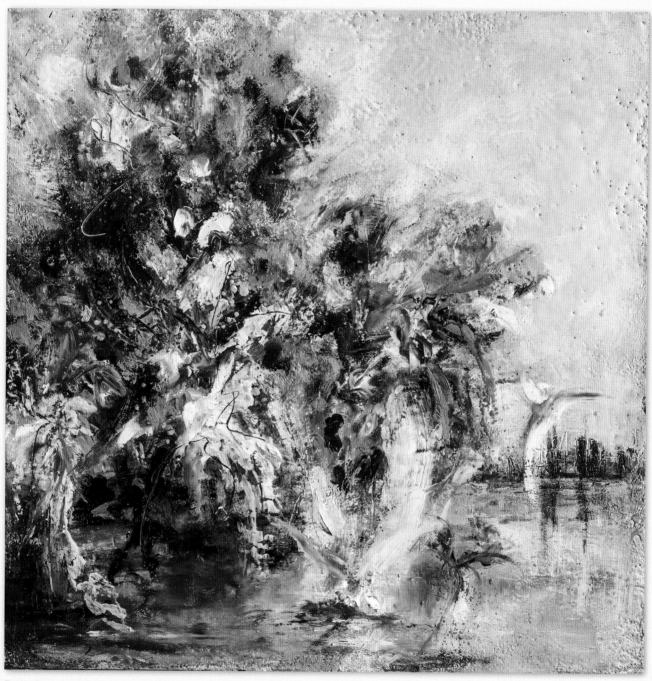

Renaissance

Encaustic on wood, approx. 20.08" × 20.08" (51 × 51 cm)

Here some blue and white oil paint was applied with the fingers and then fused.

Lines were engraved spontaneously, using a potter's needle.

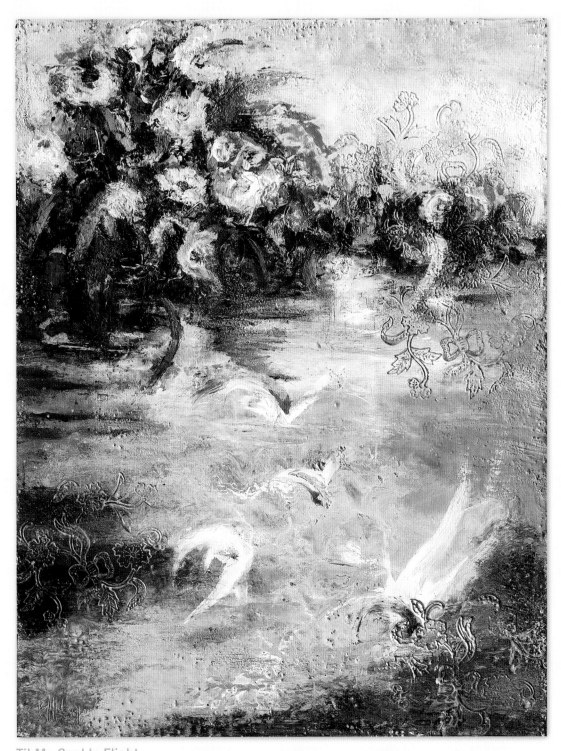

Til My Soul Is Flight

Encaustic on wood, approx. 24.02" × 17.32" (61 × 44 cm)

In this painting the same technique was used as in the previous work, *Renaissance*, and relief imprints were added using an Indonesian tjaps.

Materials and Supplies

Materials

In encaustic painting, a hot, liquid encaustic medium is used as the binder for the color pigments. **The most popular encaustic medium is a mixture of beeswax and damar resin crystals.** There is also another encaustic medium consisting of a mixture of microcrystalline wax, beeswax, and damar resin or carnauba wax. Waxes can be made from animal, vegetable, and mineral raw materials. They all have a basic common characteristic, which is that they are all water-repellent (hydrophobic). Encaustic paint is composed of beeswax, damar resin, and pigments.

Beeswax

Beeswax is produced by honeybees, which use the wax to build their honeycomb. A wax platelet from one bee weighs about 0.0008 grams. It takes about 150,000 bees to produce one kilogram of beeswax.

Beeswax is colorless to white when it is secreted by the bees. The golden yellow color of the wax in the combs comes from the propolis and pollen oils that are mixed in by the bees. Honey, aromatic substances in the wax, and propolis and pollen give the beeswax its unique fragrance.

The wax is not pure after it is extracted, and therefore has to be purified. The color of beeswax varies from light to dark yellow. To obtain white beeswax, it must be lightened. This can be done mechanically by using carbon filtration. An equally harmless method is to bleach the beeswax in the sun.

Chemically bleached beeswax is produced by oxidation, by adding acids such as sulfuric acid and oxalic acid, as well as hydrogen peroxide, which should not damage the quality of the wax. However, the colorants aren't removed, and this can cause darkening over time. Likewise, the pigments may react with the oxidizing substances.

It's therefore a good idea to use mechanically bleached wax for encaustic work. Many artists also work with naturally purified beeswax, which retains its warm yellow tone.

Resin is added to get the beeswax to harden, or cure, completely. This raises the melting point and prevents the unsaturated carbonic acids from crystallizing out. Beeswax has excellent archival properties: it is water resistant and has an antimicrobial effect, which fights against molds and other tiny organisms. It also protects the pigments mixed with it from UV rays. Its melting point is 143.6° F to 150.8° F (62° C to 66° C).

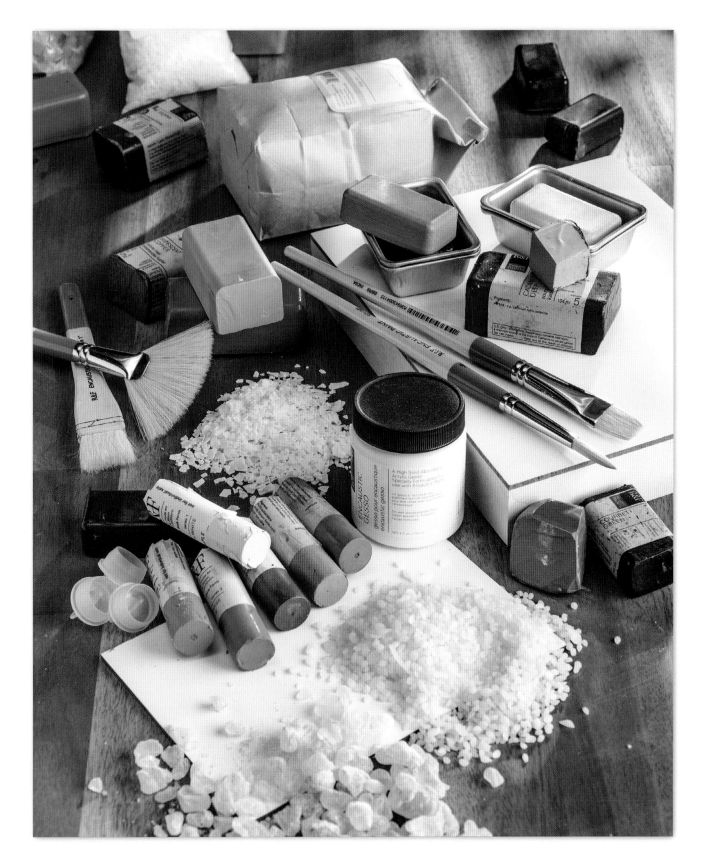

Microcrystalline Waxes

Microcrystalline waxes belong to the group of microwaxes which are refined from petroleum. They occur in complex mixtures, and, depending on the proportions of raw materials and their properties, are subdivided into hard or plastic waxes. Their melting points vary.

Microwaxes are opaque to translucent and can show different degrees of luster. Their color varies from brown to yellow to white. Microcrystalline waxes, like beeswax, are used in the cosmetics and food industry and are considered safe for humans and the environment.

They have a significantly higher plasticity and sticky quality, compared to beeswax and paraffin waxes.

Artists use this property when they paint on flexible supports such as canvas, because the canvases can then be rolled up and shipped. The microwax is flexible and does not break. Beeswax, in contrast, is brittle and therefore only applied on solid supports such as wood panels, or on canvas stretched on wood panels.

Microcrystalline waxes cost less than beeswax, but they also don't smell very good. The higher the oil content, the more pungent the smell of oil.

However, the biggest disadvantage of microcrystalline waxes is their poor long-term stability in relation to oxidation. They have limited UV-resistance; with longer-term exposure, this leads to oxidation of the upper surface, and they darken and change color to become yellowish. This is less of a problem with dark-pigmented wax, but the yellowing is visible in the lighter basic tones, white tones, or glazes. Their melting points are 140° F to 194° F (60° C to 90° C).

Carnauba Wax

Carnauba wax is derived from the leaves of the carnauba palm. Carnauba is the hardest natural wax. Its color is yellowish or greenish.

Carnauba can be mixed with beeswax, to make it harder and more heat resistant. It has good moisture-resistant properties, and is fragrance free. However, it is very brittle. Its melting point is 176° F to 188.6° F (80° C to 87° C).

Candelilla Wax

Euphorbia antisyphilitica is a bush that grows in North America and Mexico. The stems and leaves are used to produce candelilla wax. It is hard and brittle, yellowish-brown to opaque. It too can be added as a hardening substance to beeswax, or mixed in a formula with microcrystalline wax. Its melting point is 152.6° F to 174.2° F (67° C to 79° C).

Paraffin

Paraffin is also among the microcrystalline waxes refined from petroleum. However, this wax has a macrocrystalline structure that has a lower molecular weight than microcrystalline wax; thus, the melting point is also lower.

Paraffin is transparent and very brittle. This often leads to the wax cracking and flaking.

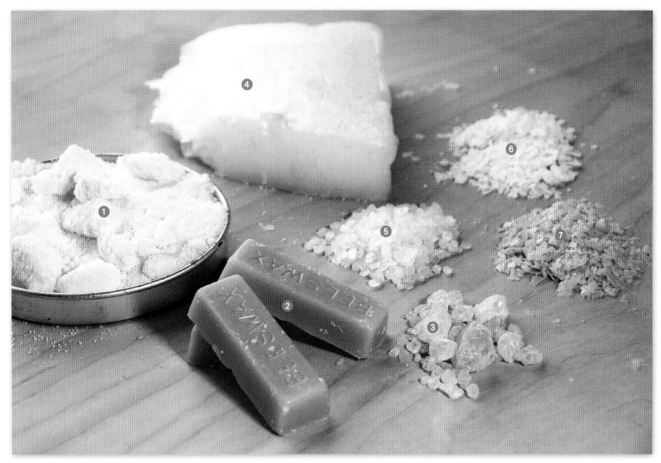

❶ Purified beeswax (pharmaceutical quality), ❷ Naturally purified beeswax, ❸ Damar resin crystals, ❹ Microcrystalline wax, ❺ Paraffin, ❻ Candelilla, ❼ Soy wax

It's possible to increase its plasticity and raise the melting point by combining it with high-melting-point microcrystalline wax. By adding 10 to 15% microcrystalline wax, the wax material becomes opaque and, with appropriate colorants, resembles the appearance of beeswax. Paraffin can be used to clean brushes.

Many artists use paraffin to pour onto existing picture material, because it is clear and transparent. However, keep in mind its extreme brittleness. Paraffin wax is the least costly wax and is also used in the food and cosmetic industries. The melting point for high quality mixtures is 129.2° F to 136.4° F (54° C to 58° C).

Soy Wax

Soy wax has a very low melting point and thus is of only limited use in encaustic painting, but is often used for cleaning brushes. It is biodegradable and has a natural oil content. A brush cleaned this way can then be cleaned with soap and water and used for other painting media. Since soy wax is obtained from a renewable raw material, the soybean, it's preferable for cleaning than paraffin, a petroleum-based product. Its melting point is 122° F (50° C).

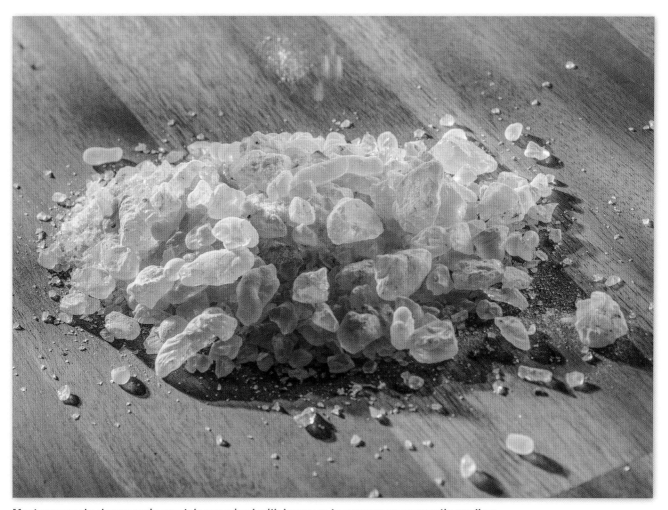

Most commonly, damar resin crystals are mixed with beeswax to prepare an encaustic medium.

Damar Resin Crystals

Damar resin is obtained from a tree native to Southeast Asia. It is light to transparent, and dusted with white.

It should not be confused with damar varnish, which contains turpentine and is highly toxic when heated.

Damar resin crystals are available in stores or on the Internet. Artists prefer the small crystals, which are the optimal size for melting.

Damar resin is most commonly mixed with beeswax to prepare an encaustic medium. It raises the melting point of beeswax and makes it possible to cure the wax and to create a glossy surface when the artwork is polished with a soft cloth. The saturated hydrocarbons of damar also prevent the unsaturated carbons of the wax from crystallizing at low temperatures. These often form a white, web-like film on the surface (this is why old beeswax candles appear rather whitish in color). This can also be removed by polishing. Its melting point is 224.6° F (107° C).

Supplies

Heated Palettes, Cans, and Containers

A palette can be any flat surface that can be heated. This is where you melt the medium and encaustic paint and keep them in molten form. An electric skillet works well as a palette for mixing paints. An electric hot plate works well for keeping cans of liquid encaustic paint and wax brushes warm. Another alternative is an aluminum pan heated from below on an electric hot plate. **It is important to have a temperature control or a thermostat that you can place on the aluminum surface to check the temperature.** You can use tin-plated cans to keep the paint molten; these let you keep several colors of paint ready for painting at the same time. Depending on your budget, you could use a cat food can, or special steel cans meant for artists' use.

Brushes along with encaustic paints in pans, being kept warm on a hot plate. Courtesy of R&F Handmade Paints.

Encaustic medium and brushes on an electric griddle; the electric skillet to the left serves as a palette.

Brushes and Other Application Tools

Always use a natural fiber brush, because the bristles of plastic or plastic brushes melt! A hog bristle brush from the hardware store is sufficient. Typically, wider natural fiber brushes are used for preparing the ground with encaustic medium and for applying the first two to ten layers of paint.

It's a good idea to have a lot of brushes. You can use traditional natural fiber brushes just as well as the more expensive hake brush, flat brushes made of very fine goat hair. Since they hold fluids especially long and release them steadily, they work particularly well for encaustic painting.

Many artists use a separate brush for each color, because the pigmented wax cools quickly and the brush can be stored without cleaning.

A palette knife and spatula are ideal tools for working with wax. A palette knife can be used to spread the wax over a large area and a spatula can be loaded with wax, to create a wax spatter or impasto wax applications.

To engrave in lines, you can use pottery utensils, as well as awls, cookie cutters, razor blades, or an Indonesian tjaps.

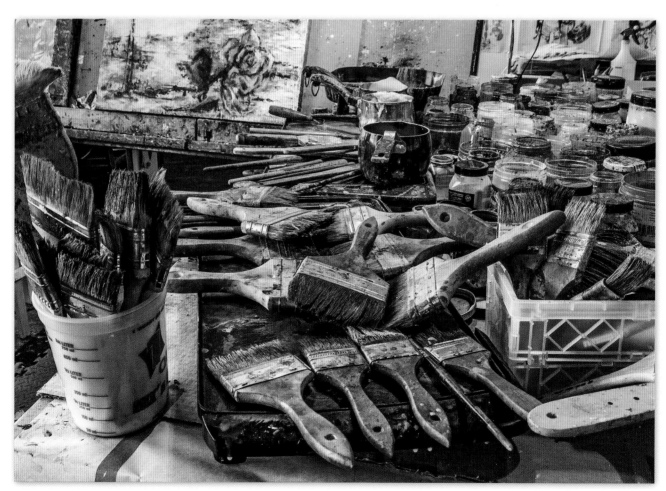

Cooled brushes that have been used for encaustic, and warm brushes on a hot plate.

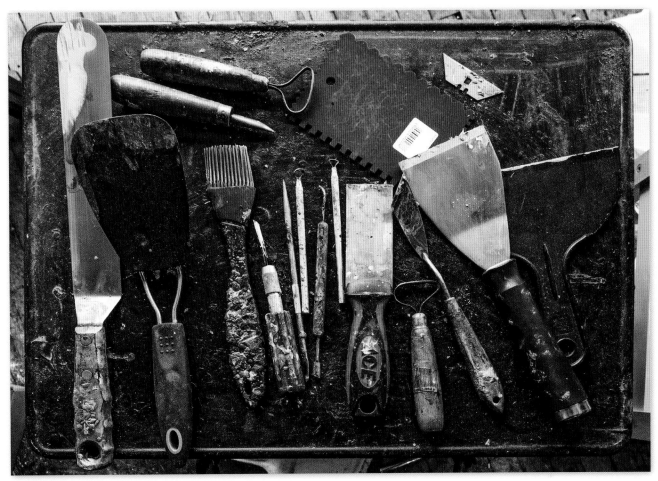

Useful tools: Cake server, kitchen spatula, silicone brush, linoleum cutting tools, pottery needle, putty knife, several modeling clay loop tools, palette knife, wallpaper scraper, scraper, razor blade, and notched spreader/scraper.

Razor blades and potter's tools are indispensable for scraping surfaces clean, for removing wax to expose underlying layers, or to create fine lines. I usually have some six to ten razor blades out, which I use constantly. They are "the erasers of encaustic painting," because they are used to remove color applications or refine color applications by creating clean contours. Since the wax sticks to the razor blade, I keep laying it back on the warm hot plate in between uses. The wax melts and dissolves off the blade. It's best to use a cloth to pick up the razor blade from the hot plate and to start using it again. Anything metal gets hot very quickly and you can easily burn your fingers. Then lay the cleaned razor blade down on the table until it has cooled off. This is also how I clean my modeling clay loop tool and my putty knife or palette knife.

The longer you work in encaustic, the more imaginative you become regarding the tools you use to design and vary surfaces.

Tools for Fusing and Binding the Layers

In encaustic painting, the wax layers are bonded together and fused with each other by heat. In the rest of the book, I will use the term "fusing" for this process. There are various tools commercially available for this.

Hot Air Gun

A hot air gun works very well for fusing the wax layers with each other. When buying it, look to see that it has several heat levels, and check that the gun is not too heavy, since otherwise it can give you arm muscle fatigue and other muscle aches after use.

Propane Torch

A propane torch can be found in any handicraft supply or home improvement store. Most artists use a propane torch when they are working over a large area and do not want to work with a power cable. The heat is very high and the fusing process is faster—but you can also rapidly lose the content of your picture, if the wax melts too fast and in an uncontrolled way. Butane torches are even hotter. You should think about whether you want to have an open flame in your studio. If you are working with textiles or stencils, it's advisable in any case to use the smaller propane torches, which are sold by kitchenware suppliers for making crème brûlée.

Painting Iron, Clothes Iron

You can use any kind of iron, but the rule also applies here: precise temperature control is an absolute must!

There are special painting irons available from art suppliers for encaustic painting. Some artists use a waxing iron, which is available in sporting goods stores for waxing skis. It is not easy to work with a clothes iron. The longer the iron remains on a surface, the faster the heat application. The wax melts, the color layers get mixed, and this can cause unwanted debris tones that you distribute over the entire surface. Any excess wax must therefore be cleaned off regularly.

It is essential to paint encaustic medium between the layers of paint, to keep the layers from mixing together. In collages or if you're using photographic elements, however, working with the iron can create smooth layers.

Lightbulbs, Floodlights

Artists use an ordinary 100- to 200-watt light bulb when, for example, they need a uniform, slow, circular radiating heat.

You need to pay attention to distance, and the painting should lie flat.

Solar Energy

When you paint in plein air, you can actually take advantage of the sunlight and concentrate it on the surface of the encaustic work by using a magnifying glass.

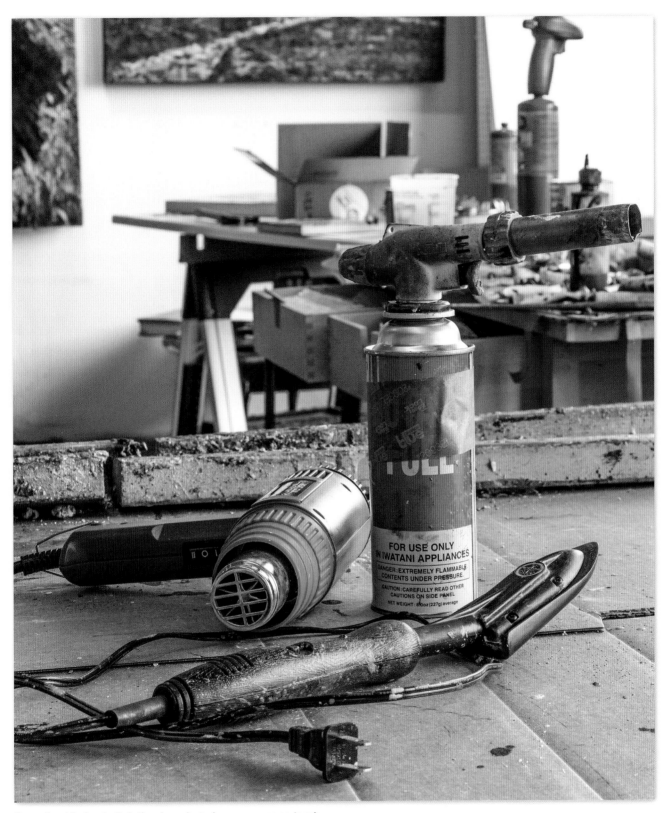

From front to back: Painting iron, hot air gun, propane torch.

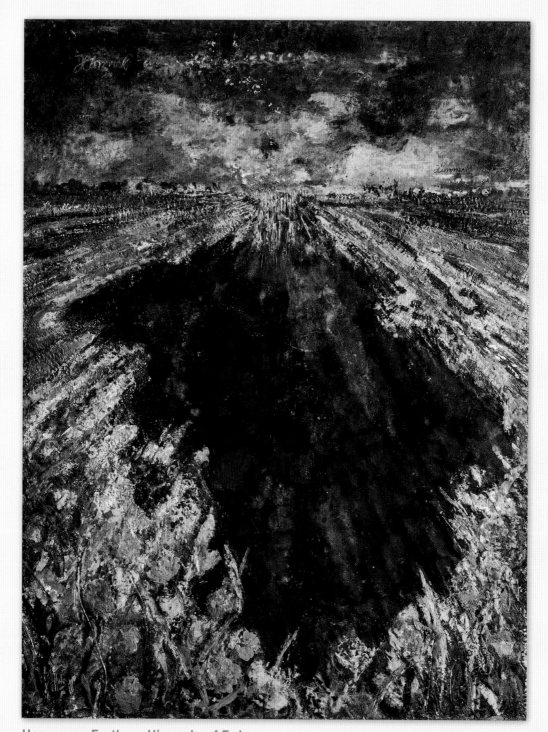

Heaven on Earth — Himmel auf Erden
Encaustic on wood, approx. 48.03" × 36.02" (122 × 91.5 cm)
In *Heaven on Earth* I set a very smooth surface in the center in blue, against an earth surface
created with a palette knife, scraped, and textured. The two different techniques are intended to
symbolize the two different planes.

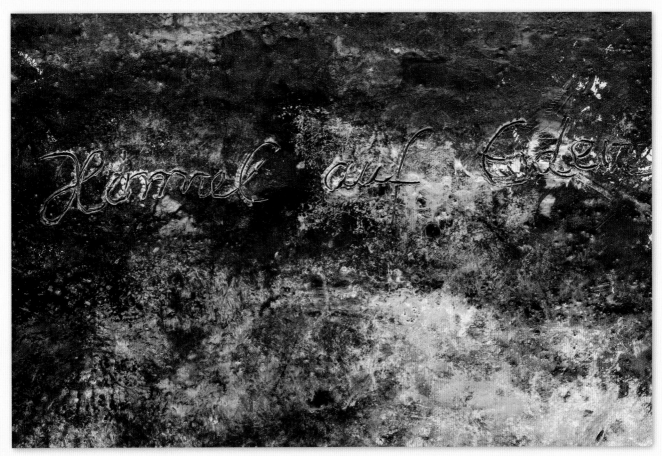

Detail. In the sky area, also smooth, I repeatedly engraved the title, both in English and in German.

Painting Substrates and Painting Grounds

Most artists prefer to paint on wood panels. The specialized art supply trade offers a high-quality plywood panel with expertly jointed side pieces for use as a painting surface, as well as a special Encausticbord™. Alternatively, you can also paint on solid wood or on high-grade plywood panels.

A basic rule: **all painting grounds or substrate materials must be absorbent, heat resistant, and, when you're working with beeswax, rigid as well.**

If you paint on paper, textiles, or canvas, these must be mounted on a solid wood substrate. Flexible painting substrates can be used under only some conditions, because, if you are using beeswax, the encaustic medium is too brittle and can flake off if the substrate curves and bends flexibly.

If you use an encaustic medium with microcrystalline wax, you can paint on paper and canvas, and even roll them up, without the encaustic medium breaking.

Other painting substrates, such as unglazed pottery, wood sculptures, plaster, stone, or clay plasters, are possible choices, as long as they are absorbent. Some artists also use sandblasted (roughened) Plexiglas panes.

The first layers of encaustic medium must be carefully fused. The aim is to create a continuous, solid structure, in which encaustic medium is absorbed into the pores of the substrate material and binds to it. This is the most important foundation for all the subsequent layers.

Without this uniform melding and adhesion to the substrate material, you risk that your picture will become loosened from the substrate by temperature fluctuations or if it's shaken. Temperature fluctuations can cause the encaustic medium to expand or contract.

Painting Substrates

Wood Panels

High-quality chipboard of birch or maple is ideal. These woods don't warp and are light in weight. MDF panels are also suitable and absorbent, but heavier in weight. Thinner chipboard, half a centimeter thick, has to be supported by a wooden frame, so that the panels cannot warp or bend. This is not a problem with thicker, two-centimeter chipboard.

Canvas

The canvas should be raw fabric and not be primed with ordinary acrylic gesso, because this ground is not absorbent enough.

Special gesso for encaustic painting has recently become available from specialty suppliers. Compared to ordinary gesso, this high-strength, absorbent ground contains considerably less binder. You can also paint

directly on the raw fabric; you do not necessarily have to prepare a ground. In general, it is recommended that the raw canvas be stretched on wood panels. Unprimed canvases are less rigid. When the wax is fused, this can cause the canvas to sag, so that the wax then collects in the middle. The larger the canvas, the better it is to use an encaustic medium with microcrystalline wax and/or stretch the canvas on wood.

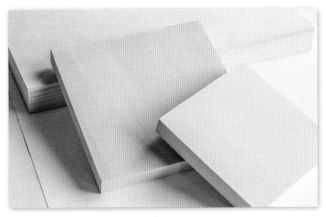

High-quality birch plywood pieces.

Paper

Basically, any absorbent paper is suitable for encaustic painting. If several layers are painted or printed on the paper, it is recommended that you stretch or fasten the paper on a rigid surface. However, if the paper becomes saturated, such as when working with monotype, or if, for example, you put a photographic print in the wax or cover it with wax, you don't need firm support, because in this case, the wax is not resting on the paper, but in the fibers. Thus, it can't flake off.

Monotype in encaustic: the wax-permeated paper becomes translucent.

Thin paper that has been saturated with wax also becomes translucent. Artists use this translucent quality for installations that feature light sources.

Works on paper can be presented in different ways:
- Mounted on wood
- Under a glass frame
- Hanging from the ceiling
- Fastened to the wall by magnets.

The wax seals the paper and protects it from UV light.

Textiles

Textiles, like paper, can be saturated with wax. Artists use fabric and encaustic in collages, in two-dimensional pictures, or as three-dimensional sculptures.

Here too, the wax can give the fabric a clear, luminous, and color-enhancing quality.

Sculptures

In general, all porous materials can be covered with wax, whether they are ceramic, plaster, cement, cardboard, wood, paper maché, stone, or simple cords or ropes that are not sealed. Here too, artists like to apply wax in all kinds of ways.

Sculptures with encaustic.

Plexiglas

Some artists who are particularly interested in installations with light have taken advantage of the translucent quality of wax when combined with transparent painting grounds, such as Plexiglas or even glass. Glass, however, is subject to temperature fluctuations, and that is not highly recommended in combination with encaustic, since if the glass expands and then contracts, it can cause cracks. Plexiglas is available in different thicknesses, which is important in that the painting ground should not be flexible. Using a wood frame can also reduce the flexibility of the Plexiglas.

Since Plexiglas is non-absorbent, it can be roughened with sandpaper, or you can start by using sandblasted Plexiglas to give the wax more surface to bind to. In general, however, because the wax doesn't bind optimally to the painting ground, painting applications and layers should be kept thin on Plexiglas.

Painting Grounds

A painting ground for encaustic should be absorbent. Many artists prefer a white painting ground for their encaustic work, since it lends the colors a unique brilliance, one enhanced by the reflected light that travels through the transparent layers.

Encaustic Medium

The first grounds are laid down using encaustic medium. At least two layers should be thoroughly fused. For a white painting ground, lay a white encaustic layer on top. Be careful, because when you fuse the next layers, this white layer can also become liquid and penetrate upward.

Titanium white, a very strong, opaque pigment, in particular tends to penetrate upward in small white droplets. This can be reduced if you apply some clear layers of encaustic medium after the white encaustic layer. These then act as a barrier for the following layers.

Gesso

It's a good idea to use a special encaustic gesso, since acrylic gesso is not very absorbent and is therefore unsuitable for encaustic work. The special gesso for encaustic dries quickly and is very easy to handle.

Gesso-Chalk Ground

A conventional gesso-chalk ground lets you sketch and draw on the painting ground.

Paper

If you want to use paper as a painting ground, it has to be mounted on wood. Again, this lets you sketch and draw on it.

Encausticbord™

The Ampersand company offers a special board for encaustic; it's available from specialty suppliers both as a flat panel and in a frame.

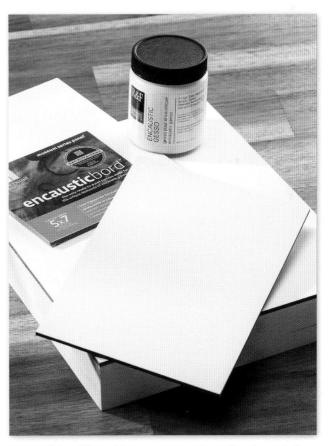

Encausticbord™ provides a ready-made surface for painting.

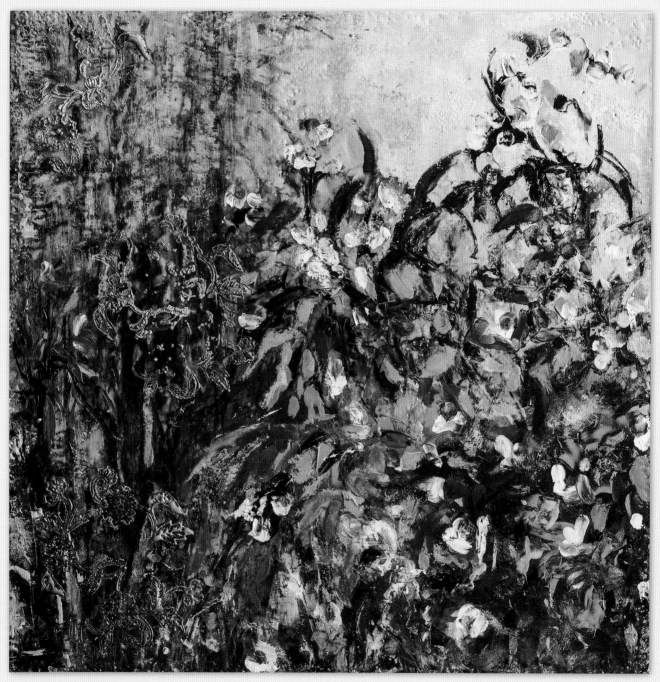

Through the Thicket Past the Blue
Encaustic on wood, approx. 21.08" × 21.08" (51 × 51 cm)
I created the flowers with only my fingers and oil paint. Then I fused them carefully.

Detail. I used an Indonesian tjaps to create both imprints and color prints, which sit on the surface.

Encaustic Medium and Paints

Encaustic Medium

Encaustic medium is the basic substance, the binder which binds the pigments; you can make it yourself, or buy it commercially as encaustic medium.

Some artists paint with pure beeswax, but most use a medium composed of beeswax and damar resin. You can make encaustic medium from different waxes, depending on your preferences, desired effects, and painting substrate.

Formulas

The most common formula is **1 part damar resin to 8 parts beeswax, 1:8**.

In hotter climates, artists use a mixture of **2 parts damar resin to 9 parts beeswax, 2:9**.

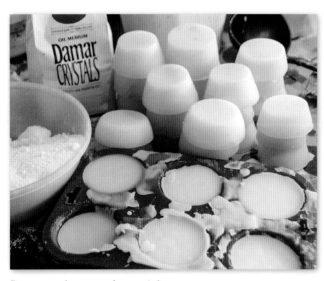

Beeswax, damar resin crystals, and homemade encaustic medium.

If you increase the proportion of resin, the melting point rises, the medium becomes harder, and is shinier and less malleable, and therefore more brittle. So it's important to be careful, because the higher the resin content, the more fragile the wax when it is hardened.

The edges of the picture are especially prone to breakage and cracks, for example if you transport the picture, or lay it on the floor carelessly. Microcrystalline waxes are mixed with beeswax and paraffin or damar resin. A common formula is **5 parts beeswax to 2½ parts microcrystalline wax and 2 parts damar resin or paraffin, 5:2½:2**. Many artists also mix just **2 parts beeswax to 1 part microcrystalline wax, 2:1**. Here too, it's worthwhile to experiment yourself. Be careful in selecting microcrystalline waxes! Some microcrystalline waxes are harder or softer than others, therefore, the proportion of hardening substance changes accordingly.

Melting the damar resin crystals.

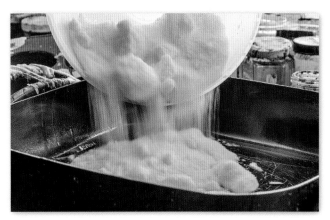

Melting the beeswax.

Making the Encaustic Medium

Making encaustic medium is simple. You need a pot, a hot plate or an electric soup pot, food warmer, or electric skillet, ideally with a temperature gauge which indicates the degrees of temperature. **Since damar resin has a higher melting point than beeswax, the resin should be completely melted first, at about 224.6° F (107° C).** Use small resin crystals, since they melt faster. When the damar resin is melted, add the beeswax and lower the temperature to 176° F to 194° F (80° C to 90° C).

The damar resin may sink to the bottom and become slightly viscous. To prevent this, stir it regularly until everything is evenly mixed and has a uniform consistency, and/or briefly raise the temperature slightly.

Since the damar resin contains residues of twigs and bark, the medium must be filtered before it can be poured into silicone baking molds (the regular household ones). A coffee filter in a coffee machine basket is ideal for filtering. Juice filters with a fine-mesh sieve or cheesecloth also work. Use a soup spoon to pour the medium through the filter into the silicone baking molds. You can loosen the cooled medium from the silicone molds by simply pressing it out of the forms.

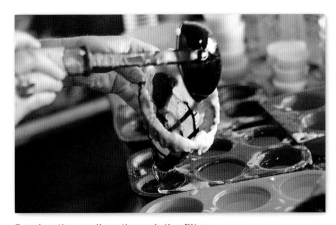

Pouring the medium through the filter.

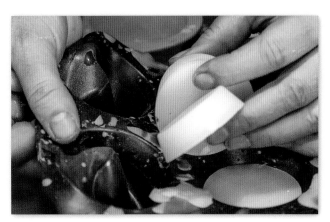

Just press the medium out of the silicone mold.

35

Encaustic Paints

Encaustic paint is encaustic medium which is augmented and mixed with color pigments. These color pigments can be mixed into the encaustic medium as powdered pigments, oil paint, or as commercial, pre-prepared encaustic paint cakes.

Encaustic Medium and Encaustic Paint Cakes

Encaustic medium and cakes of paint are also available commercially ready-made. In the paint cakes, the fine particles of the pigments have been uniformly dissolved in the wax through a highly professional production process. R&F Handmade Paints, for example, offers about 80 colors in their encaustic paints.

The paint cakes are highly enriched with pigments. Therefore, they are quite easy to portion out and then mix with liquid encaustic medium to dilute them. This makes the paint cakes last longer. The more encaustic medium is mixed in, the more transparent the paint is.

Encaustic Medium and Oil Paint

Encaustic paint can also be prepared by thoroughly mixing encaustic medium and oil paint together.

However, you should not exceed the mixing ratio of 30% oil paint to about 70% wax, so that the consistency of the wax is maintained. Oil paint makes the medium softer and the encaustic paint becomes duller and harder to polish to a high gloss. You can press out the oil paints on an absorbent paper towel for several hours before you use them and let them sit, to extract the oil from the paint. You can mix the oil paint directly into the liquid medium and then stir everything well with a brush, until you have a uniform consistency.

Oil paints, oil sticks, oil pastels, and pigment sticks.

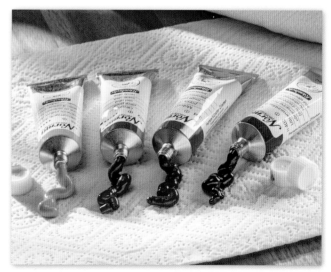

Oil paints, from which the oil is extracted.

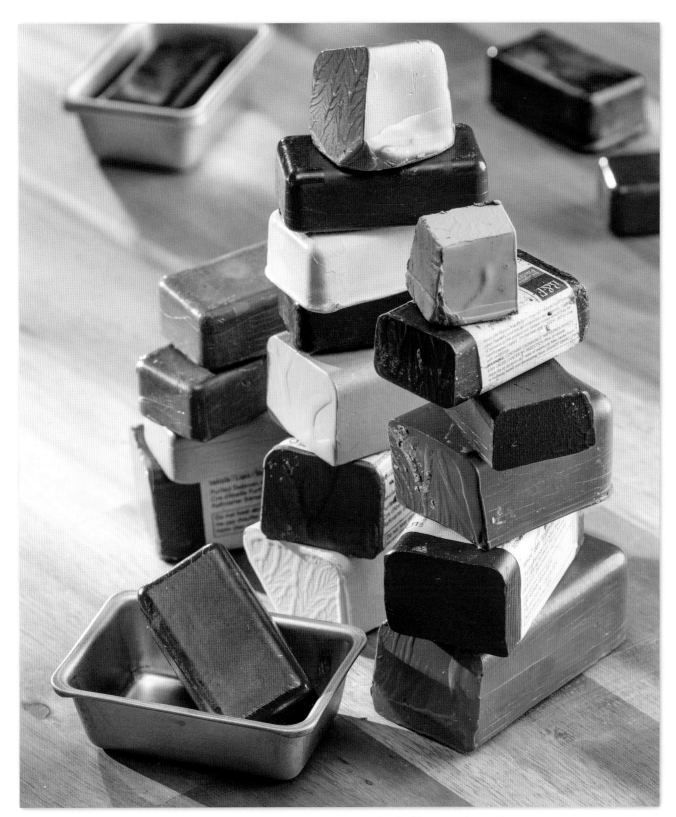

Pre-prepared encaustic paint cakes are easy to portion out and mix with liquid encaustic medium.

A brush saturated with liquid encaustic medium is loaded with pigment.

The pigment-loaded brush is dipped back into the encaustic medium.

Encaustic Medium and Powdered Pigments

Many artists use powdered pigments, and mix them into the encaustic medium. When doing this, observe the safety precautions described in "Special Instructions for Working with Wax" (pages 12–13).

The pigments can only be considered safe when they are suspended in encaustic medium.

One trick is to first dip the brush into the liquid medium/wax and then dip it into the pigment. This way, the pigment is immediately bound to the medium and no pigment particles go flying into the air. Immerse the brush in the liquid medium again and stir in the pigment.

Encaustic Medium and Oil Pastels

Oil pastels contain high-grade pigments, but also wax and oil components as binders.

When the encaustic medium is added to them, the odor and the hardness of the medium change; in addition, the color becomes more matte.

They are not recommended as a pigment source, but you can achieve impressive effects with them, when they are used as a painting medium on the encaustic surface in mixed-media technique.

Note, wax crayons are not recommended. The color is usually not light-fast, and the wax is paraffin and contains a large amount of binders and additives.

Encaustic Medium and Pigment Sticks

Pigment sticks are high quality oil sticks available from R&F Handmade Paints. They contain oil paint with highly enriched pigments and natural waxes. Unlike conventional oil sticks, they contain no fillers or additives. They have a soft consistency, similar to a lipstick. It is very easy to cut small pieces from the pigment sticks and add the encaustic medium, to preserve the pigmentation.

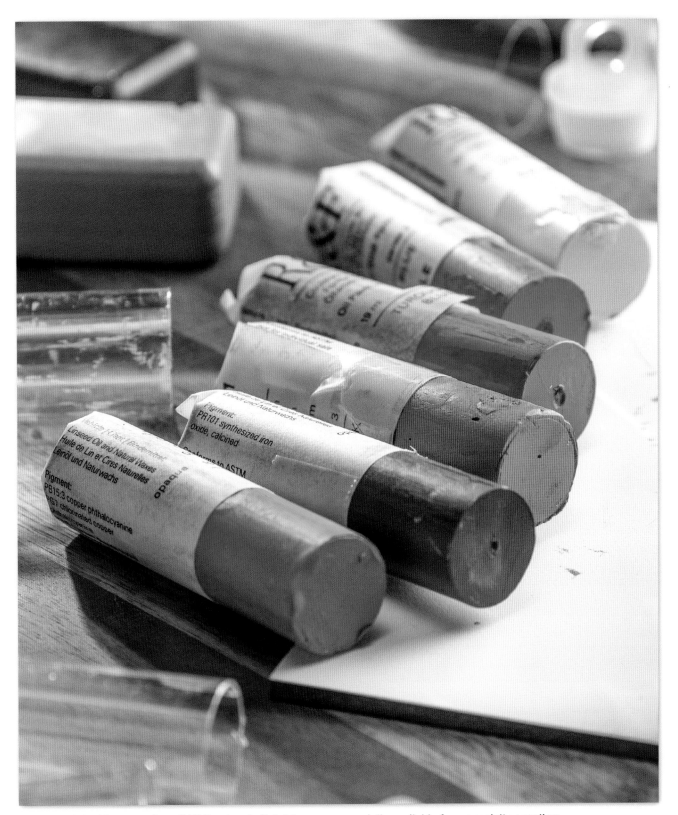

Pigment sticks (these are from R&F Handmade Paints) are commercially available from specialty suppliers.

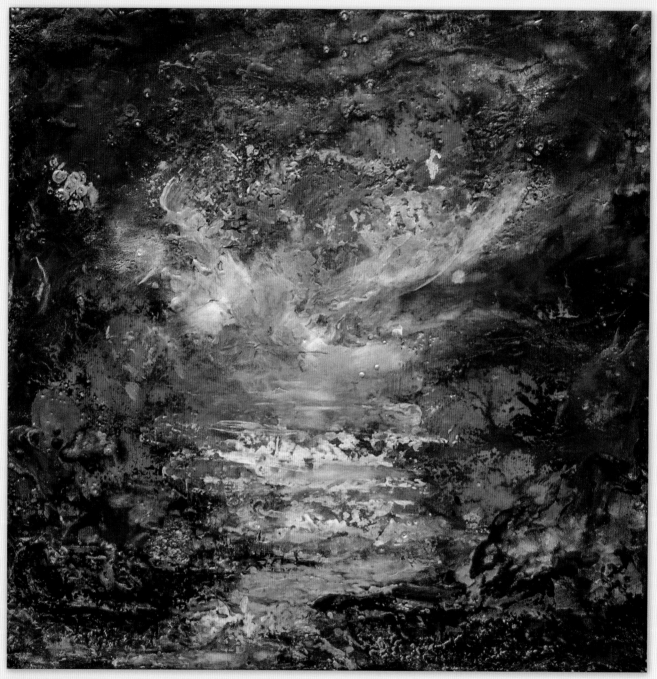

Aeon (Passage)

Encaustic on wood, approx. 15.98" × 15.98" (40.6 × 40.6 cm)

Here the paint was applied in part with a palette knife and in part spattered on.

The chestnut brown area consists of rubbed-on oil paint, which I then fused.

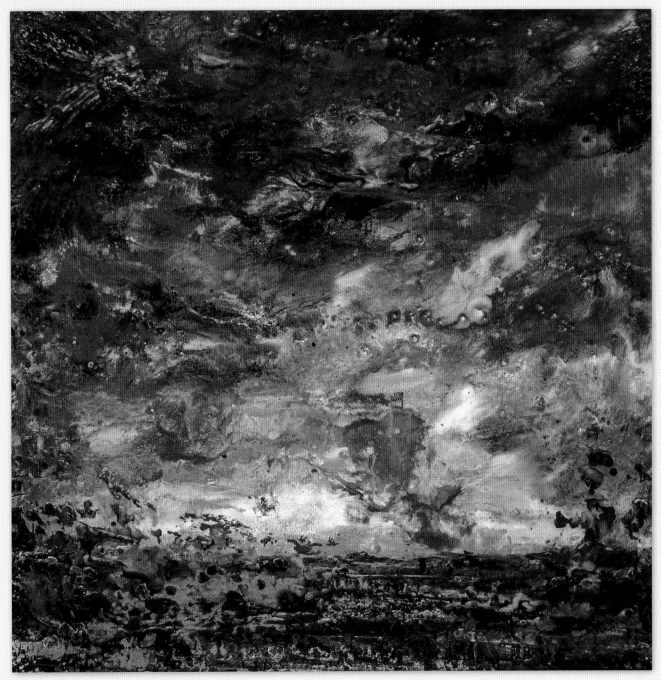

Aeon (Touch Down)
Encaustic on wood, approx. 15.98" × 15.98" (40.6 × 40.6 cm)
In this picture, I used the same technique as in the work *Aeon (Passage)*.
The paint, applied with a palette knife, is only lightly fused and so lies on the surface.

Starting Out

Preparing the Ground

The first two layers are the basis for all further painting applications. So special care is required when fusing the layers. It's important that the wax is solidly bonded with the painting ground. Paint your first layer quickly and smoothly. The wax cools in 2 to 4 seconds!

Only when the wood or the painting substrate is completely covered with wax, do you fuse this layer using a hot air gun or propane torch. This is especially important if you are using a propane torch, so as not to burn the wood surface.

Use small, circular movements to fuse the wax layer. You see how the wax becomes liquefied and shiny. Don't stay in one place too long, or you will create a hole in the wax layer and you may even burn a dark spot into the wood.

Hold the propane torch or hot air gun at a slight angle to the picture surface. When the entire surface is fused, let it cool down until the wax hardens. Then take a razor blade and scrape away the excess wax along the fiber course of the wood, that is, with the grain, for as long as it takes until you have a smooth surface again. Next, apply the second ground and repeat the process.

You scrape away the excess wax with a razor blade from the second application too. With smaller pictures, it is not absolutely necessary to remove the excess wax with a razor blade, because it's easier to keep an overview. With larger pictures, this technique gives you an advantage because it ensures, first, that the whole surface has been carefully covered with wax and fused, and second, that there is little unevenness. Even if more wax has been applied to one point than elsewhere, this will be scraped away again to make a uniform surface application.

Melting the encaustic medium.

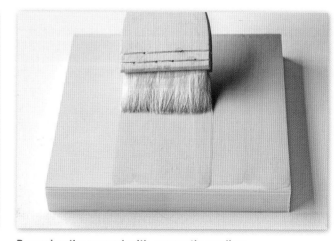

Preparing the ground with encaustic medium.

This is particularly important if you want a smooth surface.

If you want to start with a white ground, make a ground using encaustic gesso (see page 31). Then the wax layers follow. As an alternative, the commercially available Encausticbord™ from Ampersand also provides a finished white painting ground.

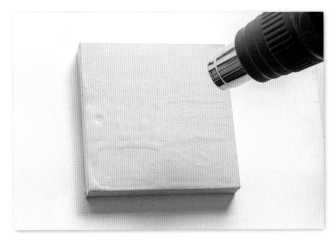

Fusing with a hot air gun.

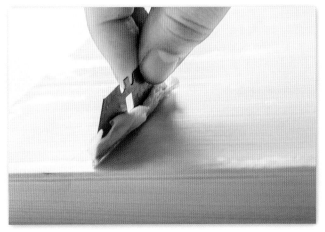

Scraping off the excess wax with a razor blade.

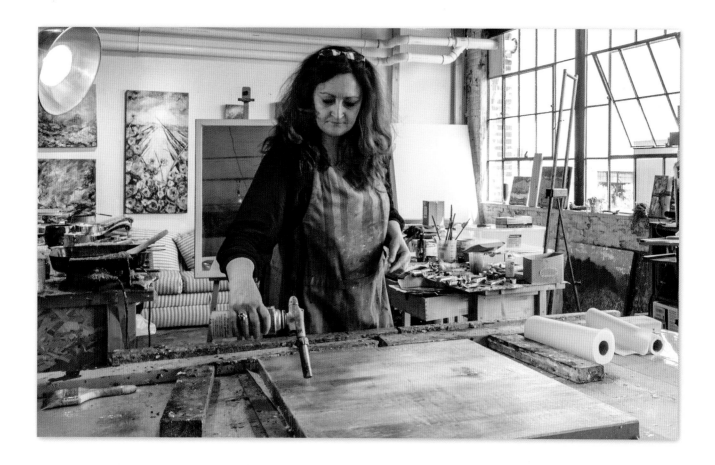

Fusing Technique

Practice how to handle the hot air gun or propane torch. Avoid holding the tool perpendicular while you are fusing and don't point the heat at one spot for too long. Otherwise, you will very quickly cause so-called "hot spots," where the wax melts too quickly and begins to bubble, or to float to the side, so that the heat discolors the wood surface.

Instead, hold the hot air gun or propane torch bent slightly, up to almost parallel to the picture surface, and move it in a circular motion over the picture surface. To reduce the amount of heat, hold it farther from the painting substrate.

During fusing, it's possible small holes will form (as if you had stuck the surface with a needle); these are rising air bubbles that burst on the surface. They usually occur if you have treated one place several times with high heat. The bubbles arise because the air that is trapped in the porous wood substrate expands in the heat and rises to the top through the wax. The higher the quality of the wood, the fewer air bubbles there are.

Lower the heat, and carefully go over the air holes again in a circular motion. Some will close immediately, but some are very stubborn and remain. For those, try using encaustic medium. Paint over the spot with it, and then carefully fuse it again.

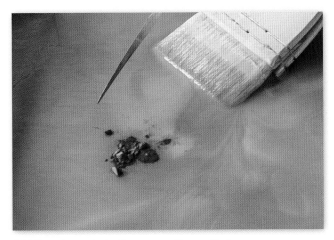

Add the pigments to the encaustic medium.

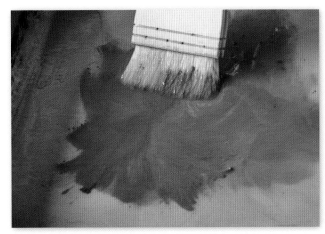

Mix everything uniformly.

First Paint Application

For the first paint applications, mix color pigments into the encaustic medium. You can either mix in oil paint or pigments, or use ready-made encaustic paint cakes (see "Encaustic Paints," page 36).

On this page, you will see the illustrated steps for adding pigments.

Add the pigment directly into the melted medium and mix the medium and the pigment very carefully with a brush. Make the next paint application quickly and evenly; a soft hake brush will hardly leave any brushstrokes at all, while a bristle brush leaves recognizable strokes. If you want to use pigment and encaustic medium instead of ready-made encaustic paint cakes, it is also true here that the paint cakes first have to be melted on a heated surface before you work with them. The melted paint is applied quickly and then fused again on the surface, to bind each layer.

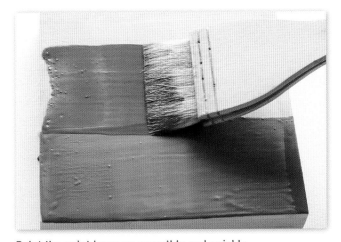

Paint the paint layer on smoothly and quickly.

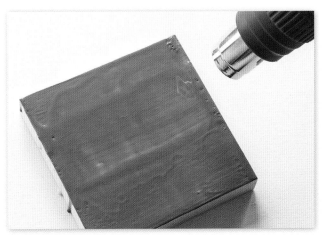

Fuse the layers.

Mixing the Paints

A heated palette is an essential tool for heating and mixing the encaustic paint/pigments and the medium. Alternatives, such as electric pans and pots, are described on page 21. Above all, it is important that your palette is equipped with a temperature control. Encaustic medium in itself is paint without pigment. It is used to dilute finished encaustic paints, to incorporate pigments or to create transparency and picture depth.

For a new color, add the desired pigment to your encaustic medium.

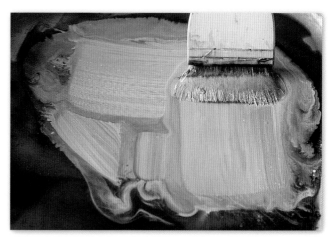

Mix the pigment and encaustic medium well, to obtain a consistent color.

Paints

Essentially, the same color theory guidelines apply for encaustic as for oil and watercolor painting. Encaustic technique uses the light of the surface (for example, a white underground) like watercolor painting does, but it also allows the painter to create light by using glazes and color tones.

In encaustic painting, you can't mix the paints with each other on the picture surface, as you can in oil painting, but you create the mixture of paints by painting in layers and utilizing the refractive index of the light that travels through the layers. If the paint is translucent, it acts as a glaze does on "old master" oil paintings. The light travels through the layers of glaze and illuminates the picture from the inside out.

It's a little more complicated, though, since we heat the paint. That is, there are many paints that change color when they are fused, and the change can vary depending on the degree of heat applied.

Transparency Compared to Opacity

Encaustic painting comes alive through the interplay of different paint applications. Light travels through the transparent layers and illuminates the picture from within. Varying degrees of transparency and opacity contribute to a picture's depth effect.

The first paint application usually has a slightly transparent effect, but already by the second application, the paint becomes opaque.

You can create changes in the transparency by your mixing ratio of pigment to medium. The higher the encaustic medium content, the more transparent the paint becomes—the more pigments you mix in, the more opaque the paint becomes.

However, you can also use transparent or opaque pigments. You can find the properties of the pigment in the printed label of the pigment or paint you use for mixing.

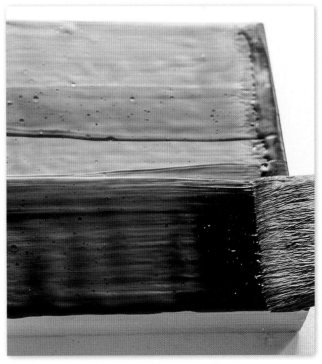

Various degrees of transparency and opacity.

When the paint cools, it interacts with the air and the refractive index of the light. It lightens and shades of colors emerge. But this goes even farther, because if you fuse the paint on the picture with a hot air gun, you also warm up the underlying layers, which blend into the top layer of paint. Thus, you're mixing the paint during this process.

This is why, so often, unrepeatable effects develop in encaustic painting. And it's an art in itself to understand them—and also to let them remain as is. Far too often, really beautiful surfaces or color nuances are lost because you want to keep working on a picture "just a little bit more," and then you can't re-create those small, unique treasures. Maybe that's why encaustic painting can become an obsession—you are constantly chasing after the beauty of what was there just a moment ago.

Cleaning Brushes and Palette

To clean a brush, dip it in hot beeswax or medium and wipe it off with a lint-free paper towel. Then you can use it for a new paint. If you want to finally clean the brush, use hot, liquid soy wax.

For this, it helps to have a container of melted soy wax on the palette. Next, dip it in warm vegetable oil (sunflower cooking oil), and then wash it with soap and water; this keeps the brush beautifully supple.

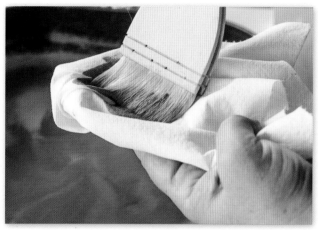

Always use a lint-free cloth to clean a brush.

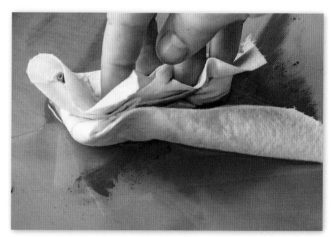

If you want to use a completely new paint, take a cloth and clean your palette.

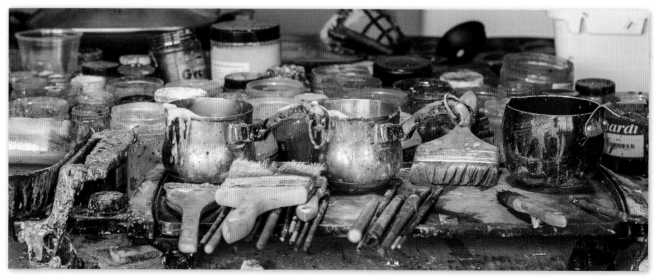

To keep your brush always ready to use, lay it on a warm palette. Unused wax brushes harden when they cool, like wax does. You'll lose precious time if you have to warm your brushes up again to get them supple.

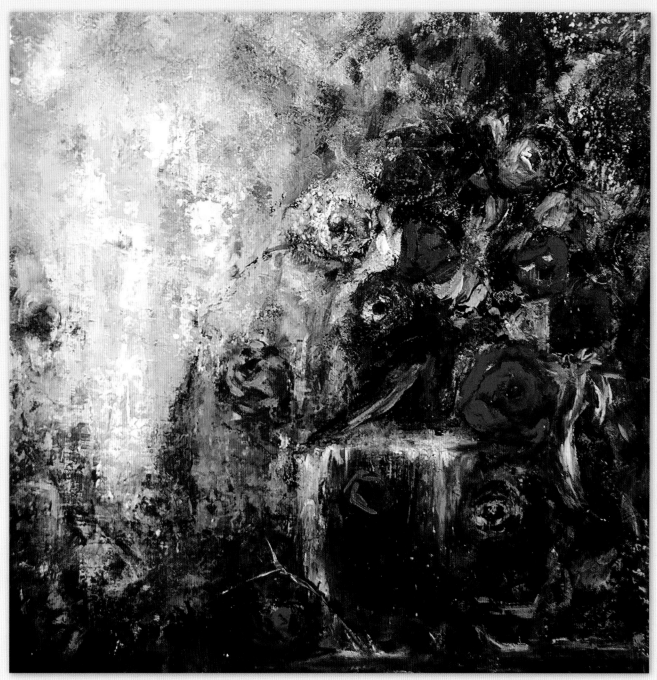

Extinguish Thou My Eyes

Encaustic on wood, 29.92" × 29.92" (76 × 76 cm)

In this picture, oil paint was applied with my fingers to represent the flowing water. Next, the paint applications were carefully fused. The background was applied with a palette knife and then extensively abraded and scraped, to reexpose underlying layers of paint.

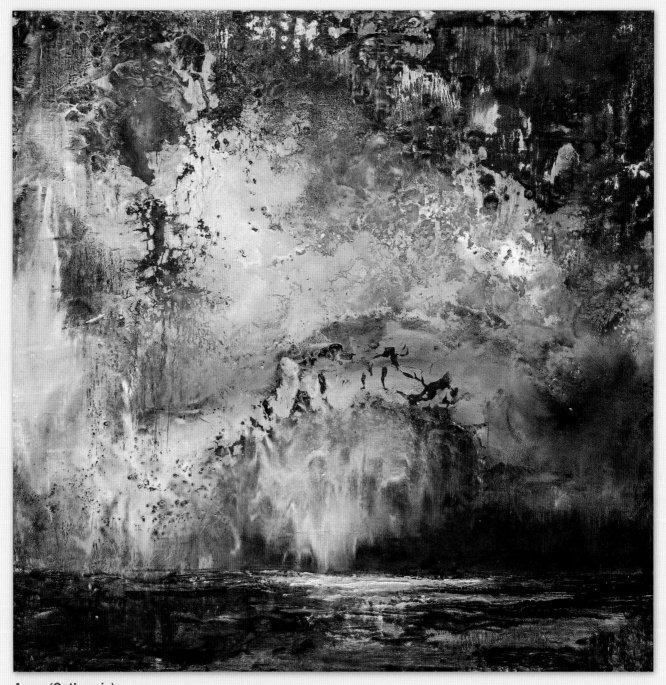

Aeon (Catharsis)
Encaustic on wood, approx. 15.98" × 15.98" (40.6 × 40.6 cm)
Here, both oil paint and pigments were rubbed directly into the surface and then fused.

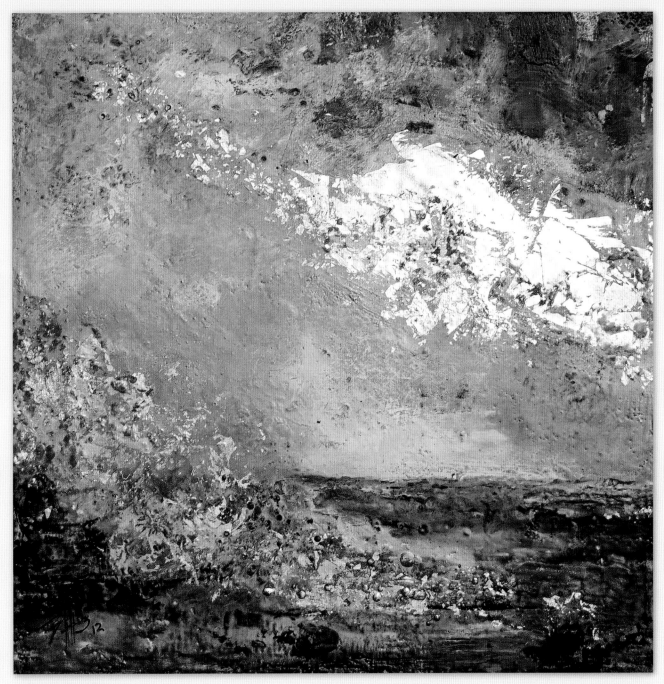

Aeon (Arc d'Or)

Encaustic and gold leaf on wood, approx. 15.98" × 15.98" (40.6 × 40.6 cm)

Gold leaf was laid on and partly collaged. Oil pastel applications in bronze and green accentuate the ground.

Smooth Surfaces

Indirect Fusing Method with a Hot Air Gun

Wide hake brushes work better to create smooth surfaces, since they release the paint in a controlled way and allow a longer brush stroke. Uniform application of paint and a warmed wood substrate reduce traces of the brush-stroke. Prepare the ground carefully, as described on page 42. For large surfaces, scrape off the excess wax after the first fusing, so it does not become uneven.

Then fuse at a lower heat and with more control, until you obtain a uniform smooth surface. For this purpose, a hot air gun is better because the heat input is low and it emerges more uniformly. A slow and careful fusing results in a surface that is reminiscent of enamel. Some artists heat their wood substrates before applying the first ground, to reduce the traces of the brush strokes from the start. Warming the wood can be done by gently applying the hot air gun, or you can lay (smaller) wood panels on a heater. If you apply warm paint to a warm painting ground, the paint flows more evenly.

Basically, smooth surfaces require slower, more careful work, both in brush application as well when working with the hot air gun.

Careful fusing results in a smooth surface that is reminiscent of enamel.

Direct Fusing Method with a Painting Iron or Clothes Iron

When using the painting iron, the surface is worked directly with the heated tool, which generates a high heat.

If you want a distinctly flawlessly smooth surface, it is advisable to increase the mixing ratio of damar resin to wax, because the surface becomes harder and the encaustic paint withstands the heat of the painting iron better. Prepare the ground with encaustic medium, and run the painting iron over the surface with a light contact. Do not apply any, or apply only a slight, pressure, since the weight of the painting iron should be sufficient. The brushstrokes are ironed smooth by the heat and disappear. After each ironing, you should wipe off any excess wax directly from the painting iron with paper towels.

It can easily happen that the high heat of the painting iron fuses the lower layers and you get an unwanted mixture of paint. Therefore, it is a good idea to apply one to two layers of encaustic medium after each paint layer, and iron them smooth to avoid mixing the layers. The encaustic medium serves as a barrier layer. The more encaustic medium layers you use, the greater the depth effect and translucence. Repeat these steps until you have achieved the desired effect.

Take note that, when you are working for a longer time, the wax must cool down in between, so that each time, the fusing process only warms the last layer. Note further, that you should not put any pressure on the painting iron, because otherwise you risk quickly penetrating into the deeper layers.

Using a painting iron.

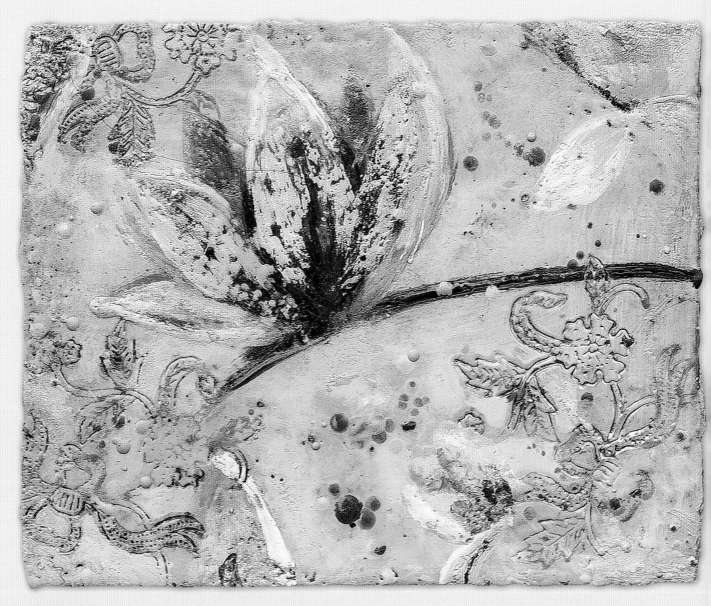

Springtime

Diptych, encaustic on wood, 8.07" × 19.69" (20.5 × 50 cm)

Springtime has a relatively smooth surface, on which the flowers were painted. I then fused very carefully,
so as not to lose the character of the impasto blossoms. In some places, they were also created with a palette knife.
In the smooth background I then fused in filigree relief imprints with the tjaps. To give the entire painting a soft,
playful look, I spattered the surface with small drops of wax (see page 56).

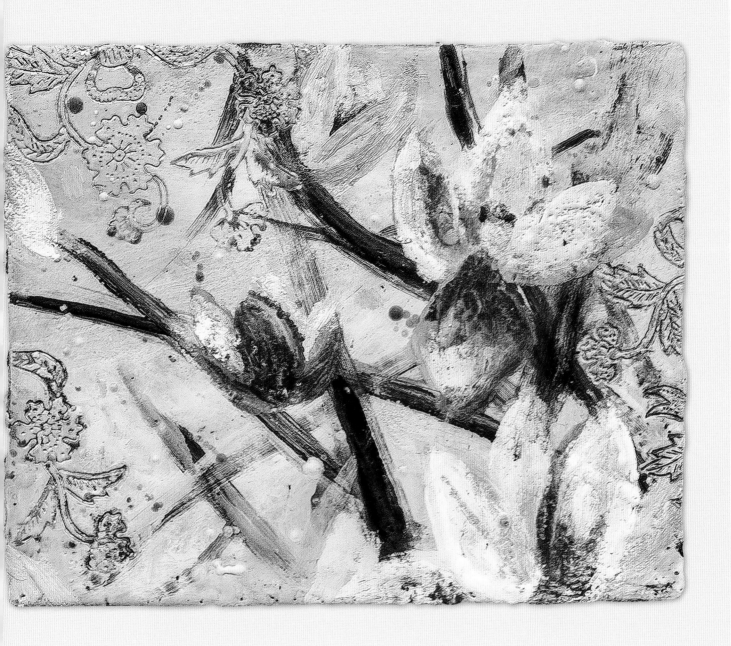

Textured Surfaces

Spattering

Naturally, paint can also be applied in very different ways. Wax drops fascinated us all as children. Spattering a picture surface with wax drops may lend a painting an unexpected spontaneity and playful ease.

Dip the brush in the encaustic paint, and let the paint drip over the painting. You can also tap the brush handle with your finger to shake the drops loose.

The following basically apply for this form of paint application:
- The larger the brush, the bigger the drops;
- The hotter the paint, the longer it remains liquid, and the bigger the drops;
- The colder the paint, the smaller the drops;
- The larger the deflection of your swing, the larger the gesture of the spattered paint turns out;
- If you cover the wax drops with paint and then scrape some of it off, really beautiful dots of paint emerge.

Scraped larger drops and hollow relief imprint.

A generous brush swing, with a corresponding drop formation.

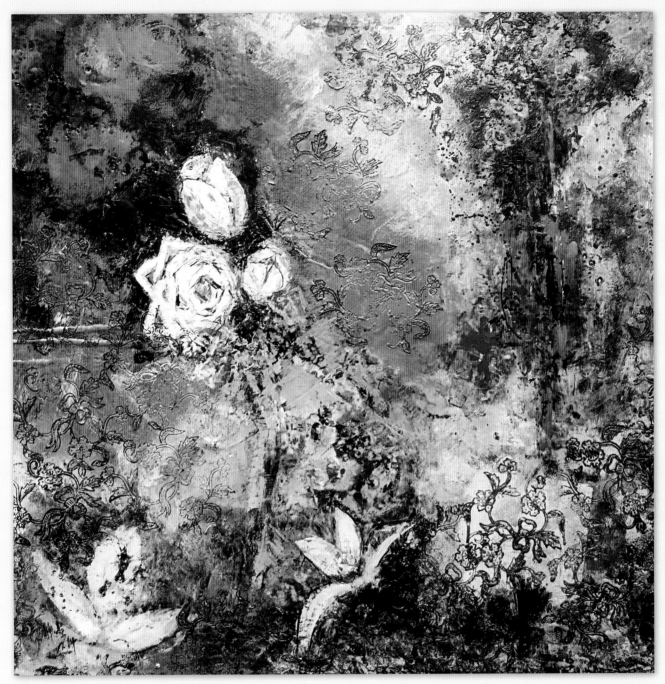

Inventing Paradise

Encaustic on wood, 29.92" × 29.92" (76 × 76 cm)

The spatter technique in the upper right quarter of the image is created using a lot of swing. In the picture composition, this represents a very powerful, and yet delicate stylistic device. Associations with blood, lifeblood, and departure are intended.

Using the Palette Knife

Another additive process to apply encaustic paint is the palette knife technique. You can create reliefs and beautiful textures in this way.

A palette knife or a cake server works well to load up with liquid wax. The process is that you first let the wax drip and then work it in with a palette knife. This yields a beautiful impasto application which, in its very irregularity, creates very interesting surfaces and contours. If you combine this with the accretion technique (see page 62), you get wonderful three-dimensional effects.

Since the impasto applications themselves are three-dimensional and lie on the surface in various levels, more wax remains stuck there if you now add a new paint application on top. You can also rub pigments or oil paint in directly; they will also remain stuck on the raised surfaces, and thus you get an enhanced three-dimensional effect.

The palette knife technique combines well with *sgraffito*, because the wax is also scraped off unevenly, due to the irregularities, and interesting shapes and color areas are again created in this way.

Rose painted with a palette knife with sgraffito.

Applying liquid wax with a palette knife.

Aeon (Downpour)
Encaustic on wood, 9.84" × 9.84" (25 × 25 cm)
Through the palette knife application of the red paint, the impression emerges of flying, whirling, or pelting-down matter.
The foreground (lower part) was also designed this way; however, the wax application was spread on more thickly here,
to suggest landscape elements.

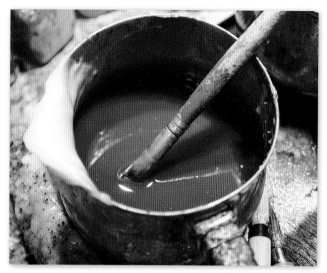

Liquid encaustic paint.

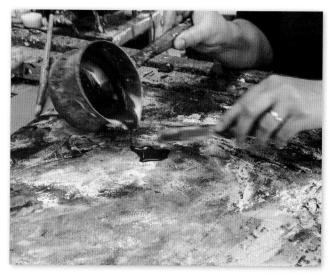

Pouring the liquid encaustic paint directly on.

Pouring

Encaustic painting offers many ways to build up a surface, without having to use a brush.

You can pour the paint directly on the picture surface and then work it in with a palette knife and fuse it.

I remove the excess wax simply by scraping it off with a razor blade. You can also dilute the poured application with a razor blade by gently scraping down the paint. This allows you to create wonderful, delicately transparent layers.

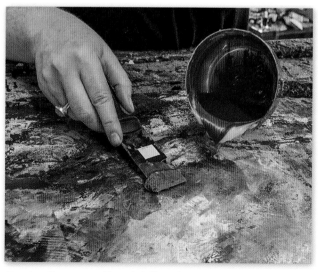

Pouring the encaustic paint directly on and then working it with a putty knife.

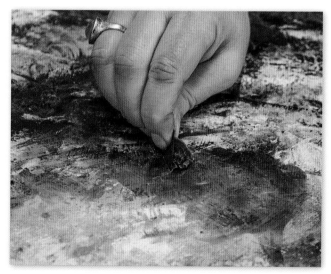

Working and scraping away the excess paint with a razor blade.

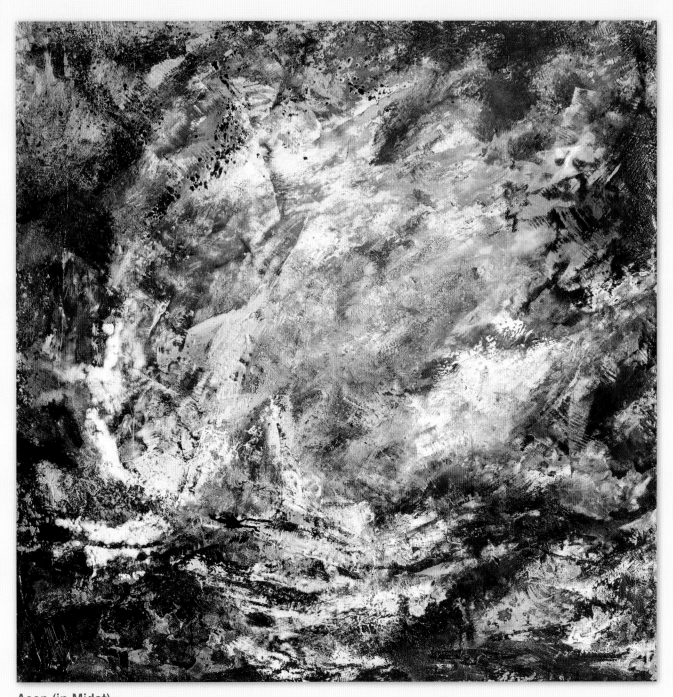

Aeon (in Midst)

Encaustic on wood, 24.02" × 24.02" (61 × 61 cm)

When the paint is poured on, unforeseen shapes and areas emerge. New shapes and surfaces
can be created by using a palette knife. I used this feature here to give the picture a colored accent.

Accretion

In this method, a fundamental property of the wax now takes center stage: Wax cools very quickly and therefore can be rapidly built up (accretion) by repeated brush-strokes. There are various methods to build up the wax. Use a brush that has hard bristles.

Wipe the wax on the brush off a little on the edge of the palette, and let it cool slightly, so that the brushstroke becomes more clearly defined. Lay your brushstrokes crosswise over each other, so that small edges and ridges are created. Or repeat the brushstrokes in the same direction/gesture and apply them atop each other. Fuse the application just very slightly, so that these edges are not melted away, but are preserved.

Some artists also prefer to roughen the first wax layers mechanically, by making furrows with a fork, for example. If these now lie against the direction of your brushstrokes, the wax remains stuck to the scraped edges and is accreted.

This way, each brushstroke leaves a visible trace, and valleys and mountains are formed in the entire work, massive accumulations of wax and repetitions. This creates a visible, tactile "story" of your painting.

Repeat the brush strokes in the same direction.

Cross-shaped brush strokes and accretions.

Roughening the wax layer with a fork.

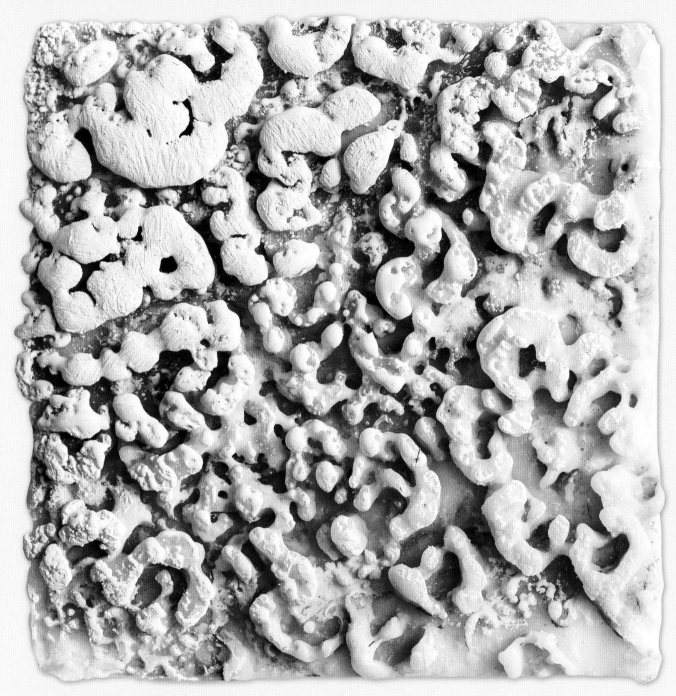

Urgrund (Primal Ground)

Encaustic on wood, 3.94" × 3.94" (10 × 10 cm)

Here the accretion became a sculpture. The full variation in height is nearly ⅜" (1 cm).

The surface should be warm,
but not so warm that you leave fingerprints.

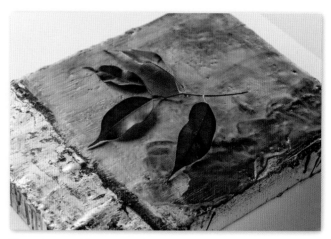

Place textured leaves on the surface.

Relief Imprint

This technique—called *cavo rilievo* in Italian—makes the malleable quality of the wax an advantage. If you have a warm picture surface, you can push objects into the wax and then remove them, thus leaving a relief imprint. *Cavo rilievo* means: hollow relief.

The picture surface should still be warm, but you should not be able to leave fingerprints.

Organic or even more solid objects are the most suitable for making a relief imprint: Plants, leaves, ropes, chains, wire mesh, or a stamp. An Indonesian tjaps especially, which is used for printing on Indonesian textiles, is wonderfully suited for the imprint technique. If you want to use organic material, for example, take leaves that have a lot of details.

Warm your surface with the hot air gun or propane torch, and let it cool a little.

Put a textured leaf with the rough side down on the picture surface. Cover it with parchment paper or waxed

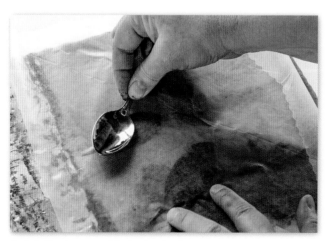

Polish the leaves with the back of a spoon.

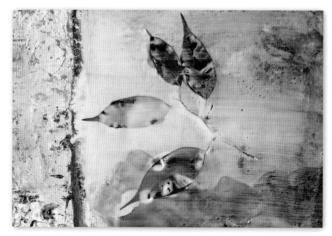

Encaustic medium layer over leaves.

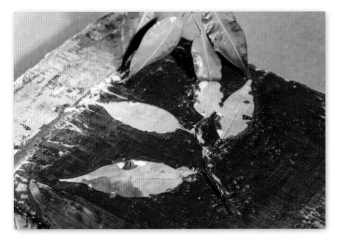

Now carefully remove the leaf,
making sure the paint is still warm.

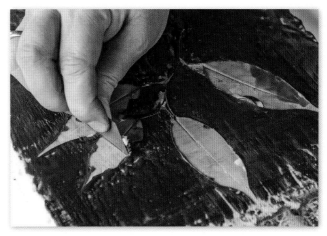

Remove excess and unwanted wax with a knife
or razor blade.

paper, and rub over the leaf with the back of a spoon. At the same time, use a polishing pressure. The aim is that when the leaf is pressed in slightly, all its details are left behind in the wax. Remove the paper again, and paint a layer of encaustic medium, and, optionally, encaustic paint over the leaf. Fuse this carefully.

Now carefully remove the leaf, as long as the paint is still warm. You can give some emphasis to the details by rubbing oil paint or oil sticks into them.

If you are working with a solid object, the same process applies as was used in the previous example. Sometimes, when the wax surface is slightly harder and colder, you can also take a hammer and lightly hammer in a rope or chain, to leave deeper marks.

Here, too, the imprints can be accentuated by rubbing in oil paint or oil sticks.

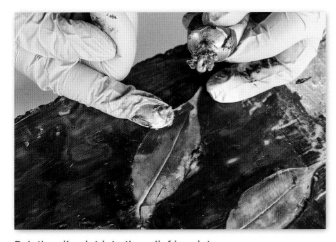

Rub the oil paint into the relief imprint.

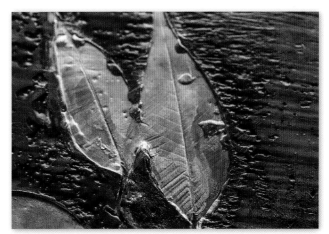

Detail of the imprint.

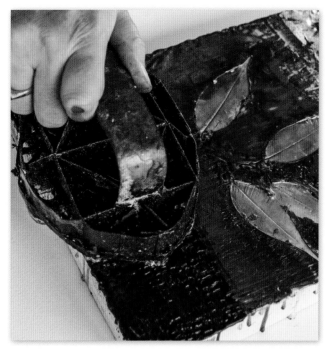

The advantage of the Indonesian tjaps is that you can also heat it. Just place it in or on your hot palette/hot plate, and warm up the stamp. Then press it on and into the picture surface. You can also set the copper stamp directly in the encaustic paint and this way load it with paint. This method creates wonderful imprints and color impressions. The hotter the stamp is, the deeper and wider the relief imprint will be. The cooler the stamp, the finer is the relief imprint formed.

Press the tjaps into the wax surface, according to whatever depth and intensity you want.

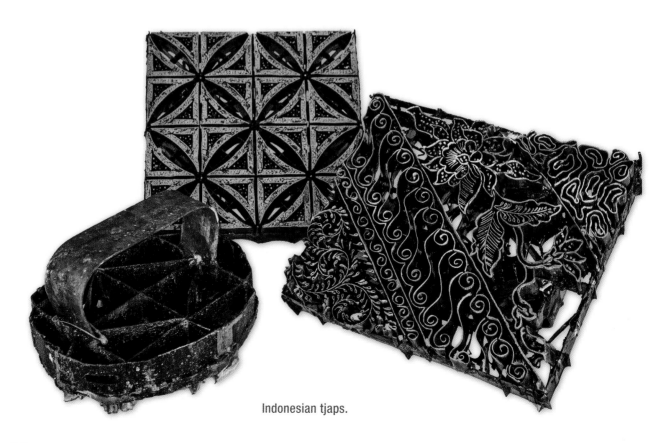

Indonesian tjaps.

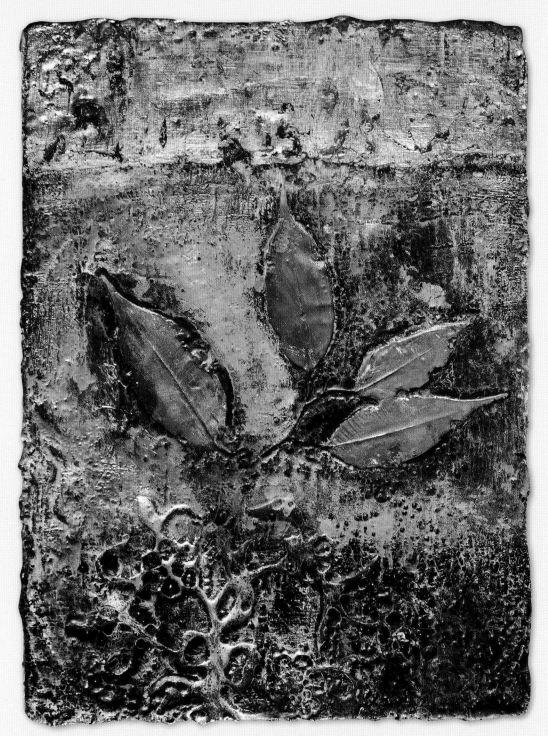

Kleine Suite in blauem Dur (Small Suite in Blue Major)
Encaustic on wood, 10.04" × 8.03" (25.5 × 20.4 cm)
Since the Indonesian tjaps was very hot, it created a broad relief imprint, into which I then rubbed oil paint. Only at the end did I use a hard bristle brush to dab on and apply the light blue paint.

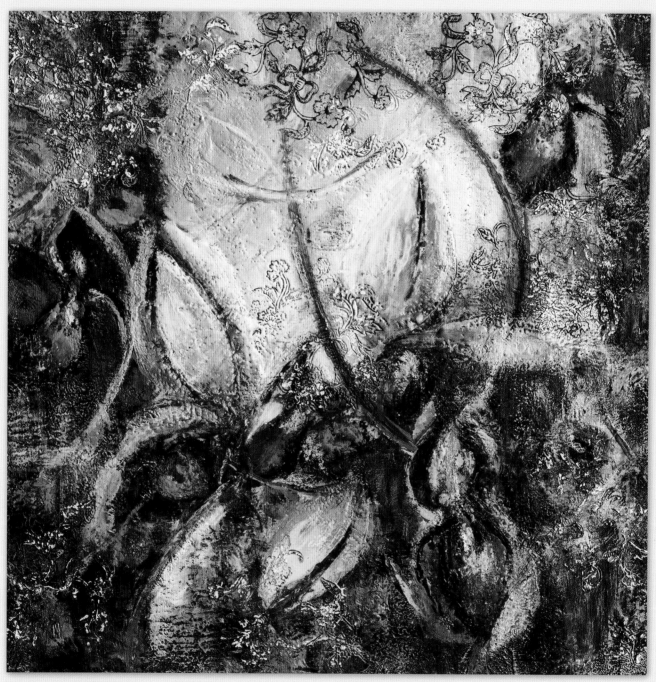

Desire (Verlangen)

Encaustic on wood, 23.62" × 23.62" (60 × 60 cm)

In *Desire,* I added fine relief imprints using a tjaps, to symbolize the complexity of the "desire."

The result is visual information on an existing picture, that symbolizes the complexity of the subject.

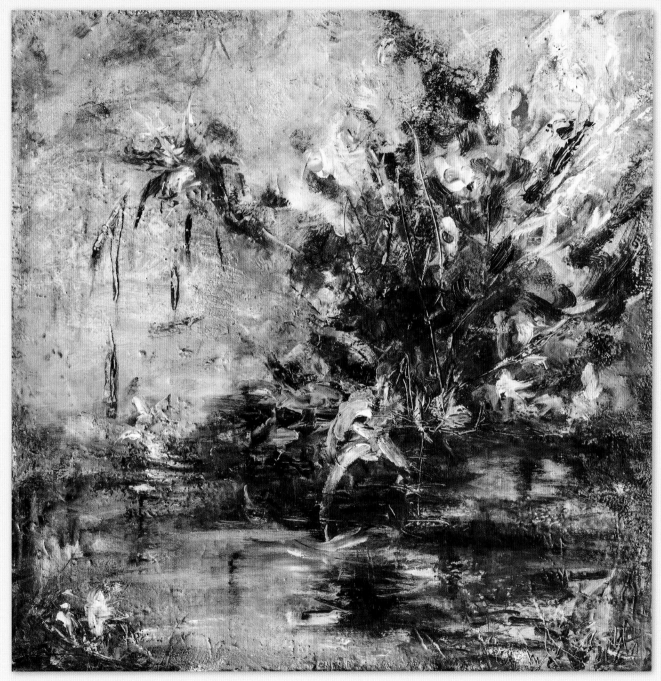

Passage du Temps
Encaustic on wood, approx. 20.08" × 20.08" (51 × 51 cm)
Petals and foliage were painted in oil with my fingers and then carefully fused.

Subtractive and Additive Techniques

Variations of these techniques can be combined together. In this process, the wax surface is carved, scratched, and engraved.

You can then fill these impressions with new paint, thus change the color character, or create precise lines.

Engraving

You can engrave lines, words, or patterns. Depending on the tool you use, the shape of the carved lines changes. If the wax is still warm, this will increase the depth of the inscription. The colder and harder the wax is, the finer the resulting lines.

You can use pointed tools, such as a potter's needle or a sharp paintbrush handle.

Intaglio

Intaglio, an Italian term, is derived from *intagliare* (= carve/notch). The term describes a technique used in gravure printing. The engraved or etched lines are filled with ink, which is then printed on paper.

In encaustic work, you can accentuate those carvings and engravings precisely, by filling them with paint. Oil paint or oil sticks work well here; rub these into the lines.

If you carve the wax surface, it creates a small rim, which you can leave there, fuse, or remove with a razor blade.

If you leave the rim, the accent is reinforced by the rubbed-in paint. Excess paint can be wiped away with a cloth. For stubborn residues, you can use a cloth saturated with vegetable oil to wipe away the paint.

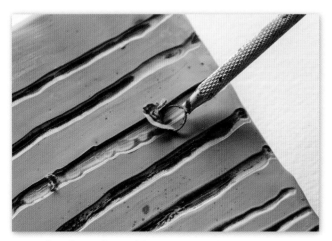

Engraving the surface with a pottery tool (modeling clay loop).

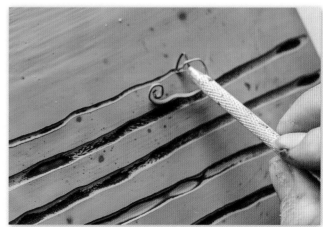

Engraving the surface with a needle tool.

Filling the engraved lines using an oil stick.

The finished intaglio. Excess paint was wiped away.

Inlay

Inlay is a decorative technique from woodworking, in which different woods are inlaid in a flat wooden surface.

In encaustic work, you engrave the desired line or shape into the wax surface, in order to subsequently fill these in with another encaustic paint. Excess wax is then removed with a razor blade or a potter's loop tool, to create a plane surface. Then, it is a good idea to apply a further barrier layer of encaustic medium on top, to prevent the paints from mixing during fusing.

Inlay is recommended when you are making wider engravings. For fine lines, it is better to work using intaglio, since the oil paint penetrates better into small, narrow impressions.

Filling in the engraving with encaustic paint.

The finished inlay.

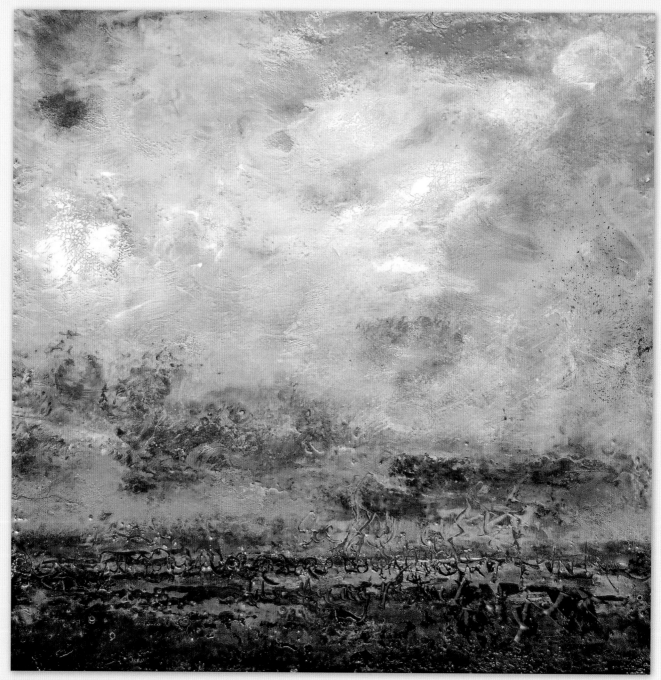

Aeon — Luftnest (Air Nest)

Encaustic on wood, 15.94" × 15.94" (40.5 × 40.5 cm)

The characters suggesting calligraphy were engraved using a small modeling clay loop tool.

This brought the blue underground to light in a way that's reminiscent of decorative painting inscriptions.

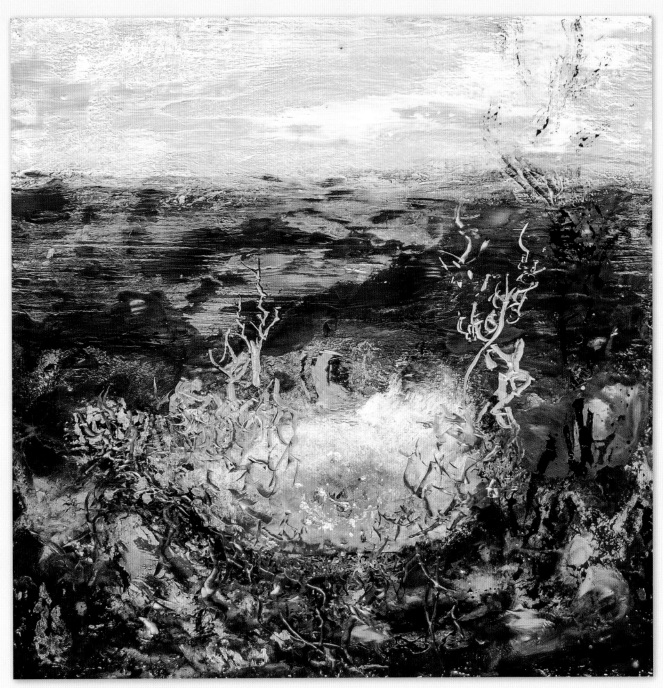

Aeon — Erdennest (Earth Nest)

Encaustic and gold leaf on wood, 15.94" × 15.94" (40.5 × 40.5 cm)

In this work, the nest was engraved in the foreground. It is difficult to paint fine lines in encaustic painting, so the technique of engraving can be used for creating fine lines. Since the first layers were painted in an intense ultramarine blue, these reemerge and accentuate the painting.

73

Sgraffito work using a razor blade against the paint application/brushstroke, before the layers are fused.

Sgraffito work using a pottery tool (modeling clay loop). After this the layers will be fused and cooled.

Sgraffito: Scraping Out Technique

The broad side of a razor blade, putty knife, or pottery utensil works well for doing sgraffito, to scrape out larger areas.

Sgraffiare (= scratch) is a technique of layering and scraping out a surface to lay bare the underlying layers.

I start most of my pictures this way. I paint the first ten layers, fuse them, and then I slowly begin to lay bare the layers. Through the layering and scraping, unexpected nuances, movements, fore- and backgrounds, interesting grain patterns, or gradations of color all emerge. It is a technique that always runs through my work, up to the end. Through this process, I receive new impulses that inspire my work and make it fascinating.

Very often, when I have the feeling that I am faltering, or that I'm not one hundred percent satisfied, I paint over the "critical area" and let myself be guided by the new beginning and the "story" of the picture, as I again uncover the layers.

There are differing ways to remove the surface, depending on which tool is used. The quality and quantity of sgraffito can also be changed by the temperature of the wax layer. Proceed carefully, because if the wax is too warm, you can scrape away more wax than you want to. Basically, after the wax is scraped out, you should fuse it again, if you do not want any visible scratch marks as a design element.

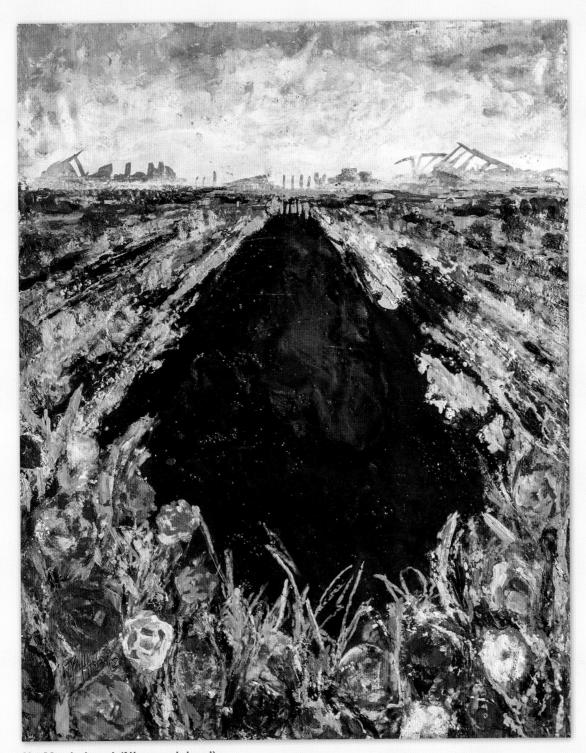

No Man's Land (Niemandsland)
Encaustic on wood, approx. 23.62" × 29.92" (60 × 76 cm)
Here the sgraffito technique was applied using a modeling clay loop,
to represent the furrows and the broken-up land.

Masking Technique for Lines and Shapes

To obtain a straight line, it is a good idea to use masking tape and a ruler to define the desired area or line. Make sure that the masking tape adheres well everywhere, so that the paint cannot run underneath it. One trick is to first paint over the masking tape and the adjacent area with encaustic medium, and only then repaint over it with encaustic paint. This lowers the risk that the colors run into each other during fusing. If you are working with a propane torch, it is particularly important that the masking tape is partially covered with wax, since otherwise it can catch fire during fusing. **Wax protects paper or masking tape from catching fire!** The wax should cool down a bit before you remove the masking tape.

If the wax is still too warm, there is a risk that the masking tape will come loose, and the underlying wax along with it. But if the wax is too cold, there is a risk that the wax will crack and the paint will flake off.

Stick the tape to the surface and press it down well. If paint has run under the masking tape, you can gently scrape and clean this away with a razor blade.

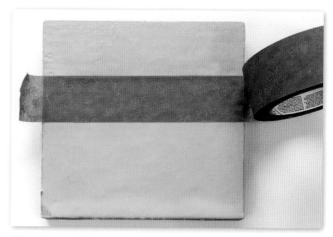

Stick the masking tape to the surface and press it down well.

You can also use tape to define more complex shapes. To make curves, it is best to use thinner masking tape. The technical process remains the same.

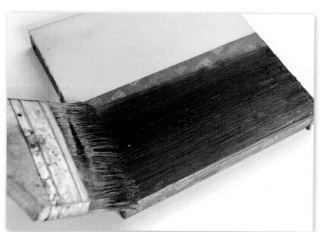

Paint the surface and the masking tape with the encaustic medium and paint.

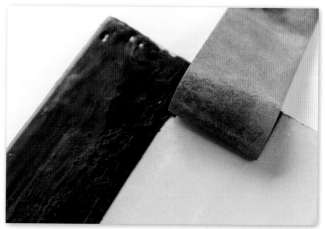

Pulling off the tape when the wax is lukewarm yields an accurate line.

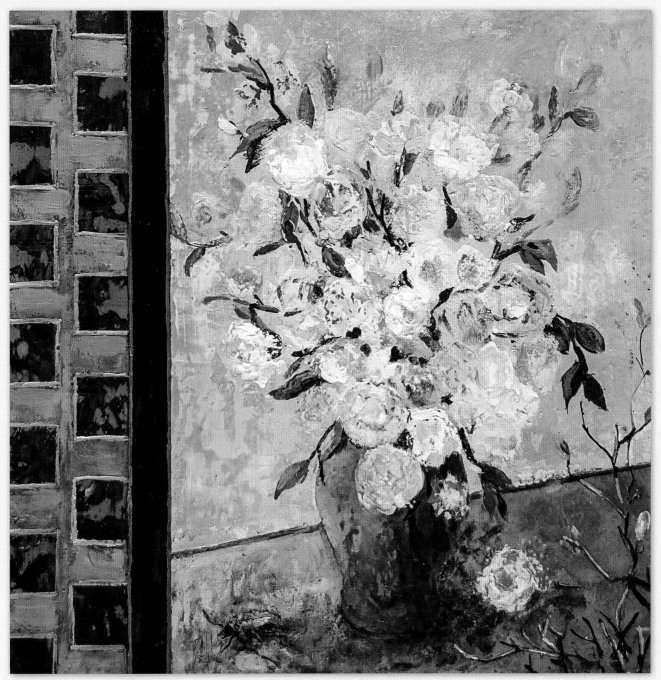

Rosenzeit (Rose Time)

Encaustic on wood, 23.62" × 23.62" (60 × 60 cm)

In this picture, the edge was taped over several times, and a meander pattern was created within the left border using the masking technique and sgraffito. Then the rims were heightened stylistically: I have outlined them with paint.

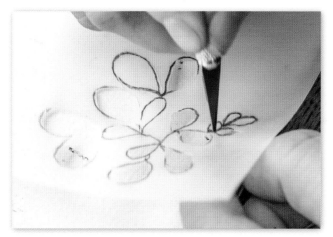

Cut out the stencil with a precision knife.

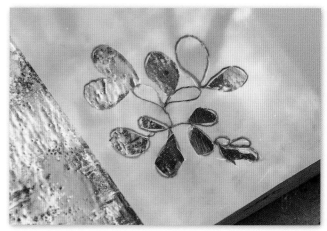

Place the stencil.

Stencils

It is easy to use stencils of paper or plastic film, which you can buy from specialty suppliers or cut out yourself. Lay the stencils on the smooth and warm wax surface, press them down lightly. First paint over them again with encaustic medium, and only then with encaustic paint, to prevent the colors from running into each other.

Fuse the paints carefully. As with the masking technique described above, you should let the wax cool down a bit before removing the stencil from the surface. Stencils are used mainly to produce complex shapes and to repeat them. Often they are used for a decorative stylistic device.

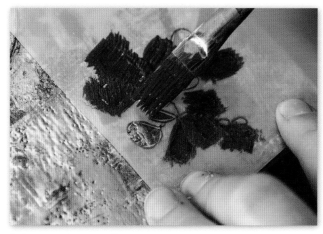

Paint over the stencil.

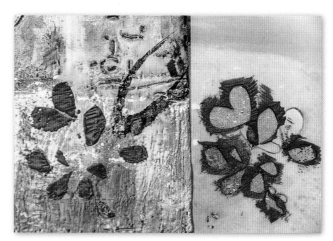

Pull off the stencil.

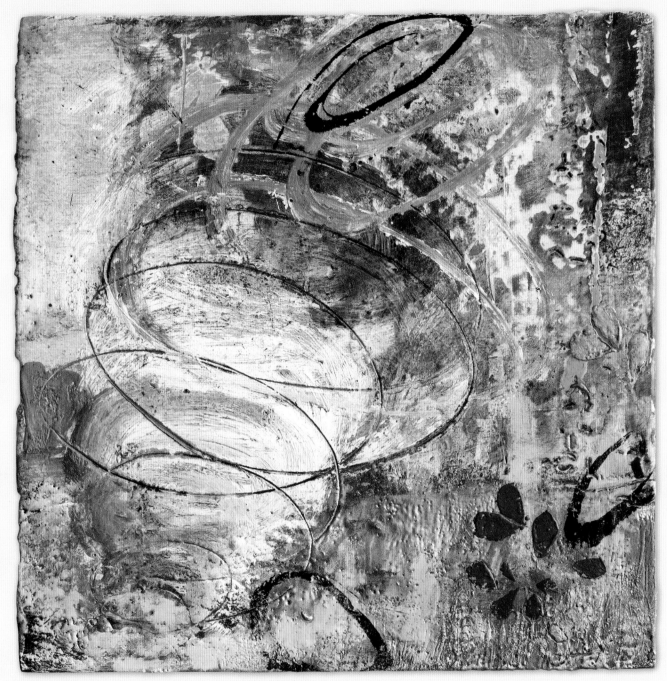

Kein schöner Land (No Country More Beautiful)
Encaustic on wood, approx. 12.01" × 12.01" (30.5 × 30.5 cm)
The stencil applications in red and gold can be seen at lower right and in the middle on the right edge of the picture.
The spiral was engraved using a potter's needle, and the gray background was created using sgraffito. *No Country More Beautiful* is an ironic title, since I had the annual tornadoes and hurricanes in my mind when I was painting the picture.
The stencil repetitions stand for the annual recurrence.

Collages

Paper

For making collages, it is best to choose lighter papers with a conventional standard weight: tissue paper, tracing paper, or uncoated paper are excellent. Once the paper is painted over with wax, it becomes transparent, or translucent.

Place the paper on your wax surface, stretch it out flat, and paint a layer of encaustic medium over it. Use this layer carefully. The paper becomes translucent and adheres to the wax in the layer beneath.

A hot air gun works better for collages, but you can also use a propane torch for fusing. Since the paper is covered with wax, it is non-flammable. Nevertheless, do not stay in any one place for too long. Fuse carefully when making collages.

If you now apply a layer of encaustic medium on top, the application becomes opaque and the paper is less visible.

You can also use textured paper, which becomes more accentuated due to the wax. And you can embed drawings, monotypes, or photocopies. The thicker and heavier the paper, the more difficult it is to completely embed the collage, because the paper will not lie completely flat and no longer adheres optimally.

A photograph on photo paper is unsuitable, because the paper is non-porous. If you are using a photographic print on Japanese natural paper, for example, then it is possible to embed it.

Paper and organic collage material.

Once the paper is painted over with wax, it becomes translucent.

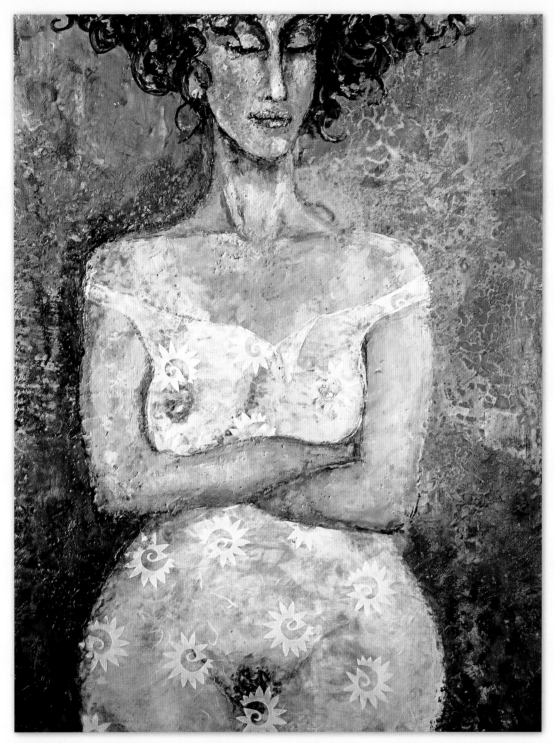

Asteria's Sanctuary

Encaustic and collage on wood, 23.62" × 29.92" (60 × 76 cm)

Asteria's garment was applied and then collaged. Beforehand, I laid paper on her body, marked off the edges with pencil, and cut out the dress to fit.

Organic Materials

As long as the organic material is completely embedded in the encaustic medium or encaustic paint, you need have no worries about the collage's durability or stability.

This applies in particular when you are using beeswax, because it is an extremely stable preservative.

Therefore, you can use all kinds of organic materials, such as petals, tree leaves, hair, or just twine and textiles, in your collage.

Due to its high adhesive property, encaustic painting works especially well for collage work, and even fragile items can be integrated well into the work.

A Place of Delight
Encaustic on wood, approx. 29.92" × 40" (76 × 101.6 cm)
In addition to the collaged eucalyptus leaves,
I also embedded the pages of an antique encyclopedia.
The border in the middle is made of metal leaf that has
been partly painted with encaustic medium. There is
a piece of tissue paper collaged behind the apple.

Metal leaf and gold foil.

Metal Leaf and Gilding with Transfer Gold

You can create special accents when you use metal leaf or gold leaf in collages; that is, you can embed them partially or completely, or just apply them to the wax picture, as you would do with gilding.

The practical part is that both metal leaf and gold leaf adhere without glue. If the picture surface is slightly warmed, the gold leaf or metal leaf adhere to the wax surface with just some slight pressure. Set the metal leaf on the surface, brush gently over it once with a wide soft brush, and the metal leaf sticks on already. Transfer gold is gold leaf pressed onto tissue paper. Turn the gold side down and apply all the gold leaf. Very carefully rub or dab the gold leaf with a soft brush and then remove the tissue paper. **Since 23-carat gold leaf is very delicate, you should not rub over it again,** either with your fingers or a polishing cloth—otherwise you will remove the thin gold leaf.

Applying and rubbing the transfer gold, removing the tissue paper.

Metal leaf is applied to the wax surface, pressed on, and partially painted over with encaustic medium.

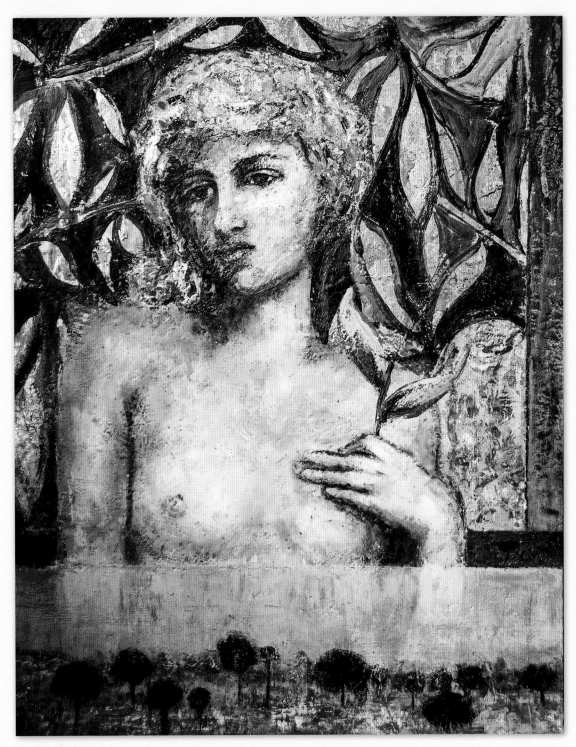

Young Gaia

Encaustic and gold leaf on wood, 23.62" × 29.92" (60 × 76 cm)

In *Young Gaia*, I have overlaid the entire upper background with metal leaf, and then painted only the negative areas to create the golden leaves.

Image Transfer Techniques

There are several techniques for transferring pictures to encaustic surfaces, both in terms of transferring photocopies and graphite drawings. For any transfer, you should prepare a smooth and warmed wax surface.

Photocopies

Keep in mind that the transfer will be inverted. Use a fresh photocopy **that has been printed with a laser printer or a copying machine**. The ink of an inkjet printer cannot be transferred.

Lay the image area on the wax surface, and press it in slightly. Place some wax paper over it, and polish over the entire area of the image with the back of a spoon (the wax paper is used to prevent the paper from tearing, which may happen during polishing).

Work very accurately here and don't omit any area, or that section will not be transferred. Remove the wax paper.

Now use a cloth or some cotton to rub acetate or nail polish remover over the paper, for as long as it takes for it to become completely damp. You can also try using water.

Now you can use your fingers to rub the paper away from the surface. The paper dissolves in small strips and can be removed.

The toner has been transferred to the image. You can fuse the transfer directly or first paint it over with encaustic medium.

Cut out the copied image.

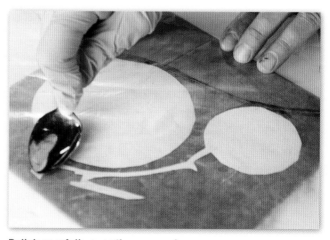

Polish carefully over the copy using a spoon.

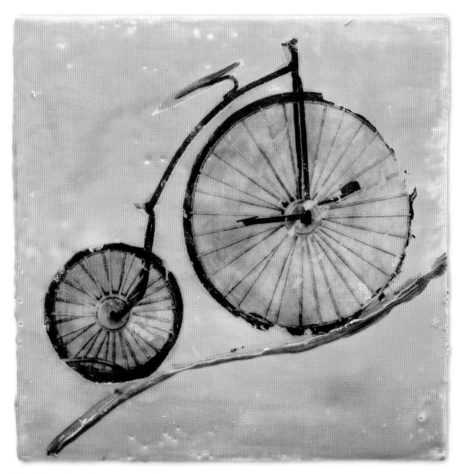

The transferred image motif.

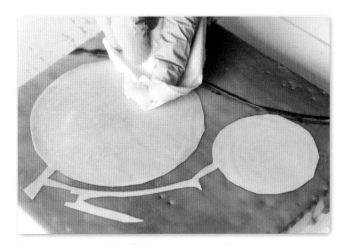

Rub acetate or nail polish remover over the paper.

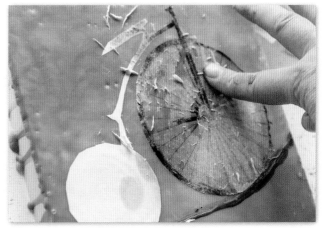

Rub off the saturated paper with your finger.

Carbon Paper

Carbon paper works well for all types of imprinting, including with manuscripts and drawings.

To do this, simply place the carbon paper with the dark side down on the wax surface and write or draw on the back with a pencil or other pointed tool. Remove the carbon paper, and fuse the imprint lightly.

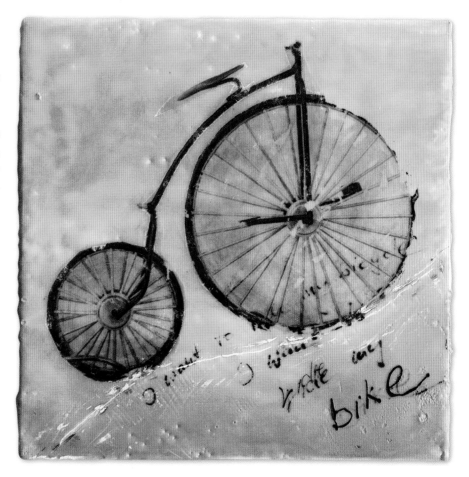

Place the carbon paper on the wax and write on it.

Remove the carbon paper.

Draw your design on either polyester film or printer paper.

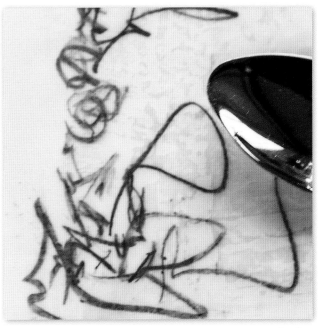

Apply your design face down on the wax surface, and polish it.

Charcoal and Graphite Drawings

It works best to transfer charcoal or graphite drawings from non-absorbent paper to a smooth wax surface. You can use parchment paper, biaxially oriented polyester film or plain printer paper.

Paint or draw your design on the polyester film or printer paper. Apply it, with the image face down, to the wax surface, and place some wax paper on top. If you are using polyester film, you do not need any wax paper, since there is no risk it will tear. Polish carefully over all the points of the design using the back of a spoon. When you lift up the paper with the design, the drawing should have been transferred.

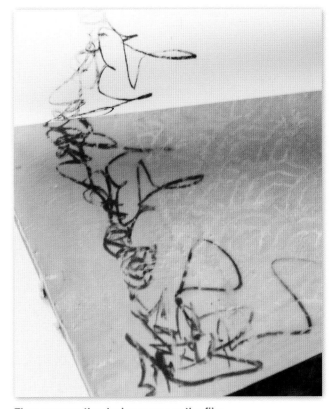

Then remove the design paper or the film.

Mixed-Media Techniques

Basically, you can combine all oil-based paints with encaustic. Encaustic paint is water-repellent, so therefore acrylic or watercolor paints are unsuitable to use.

It is very enjoyable to work in mixed-media techniques, but note: the higher the proportion of other media, the more issues about your painting's durability.

Oil Sticks, Pigment Sticks, Oil Paints

You can paint with oil sticks, pigment sticks, or oil paints directly on the wax surface. The wax on the surface should be cold. Depending on the oil content, the paint stays moist longer and smears easily. Let it dry, then cover it over with the encaustic medium, and fuse lightly.

You can also fuse the oil paint directly. You can create beautiful effects if the oil film on the surface breaks, since the wax lying underneath melts. **However, this generates gases that are harmful to your health, so please take health precautions, and work wearing a filter mask.**

Paint directly on the cold surface using an oil stick.

Fuse the oil paint lightly.

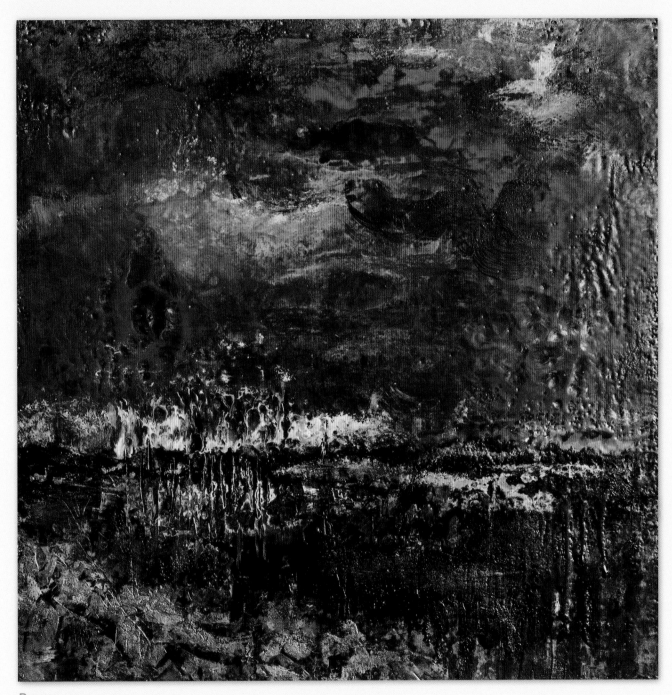

Daraa

Encaustic and oil sticks on wood, approx. 24.02" × 24.02" (61 × 61 cm)

Here I worked with a palette knife, fused intensely, and painted with both oil sticks and oil pastels. In this process, gorgeous outbreaks of the red paint emerged, which I have not been to able reproduce again even to the present day.

My assumption is that one of the oil pastel sticks had a high paraffin content, which caused the red color to separate out.

Oil Pastels

Oil pastels contain mineral waxes. Mineral wax and beeswax react slightly as repellents. Therefore, if you paint or draw on the surface with oil pastels, the mineral wax will react differently to the fusing process than the beeswax will. It fuses into small pearling movements. You can also take advantage of these as interesting, additional design elements.

When working with graphic elements, the sharp lines are lost during the fusing process, but you can accentuate these again by using a razor blade.

Painting or drawing with oil pastel directly on the picture surface.

Here green, gray, and white graphic elements have been added to the picture.

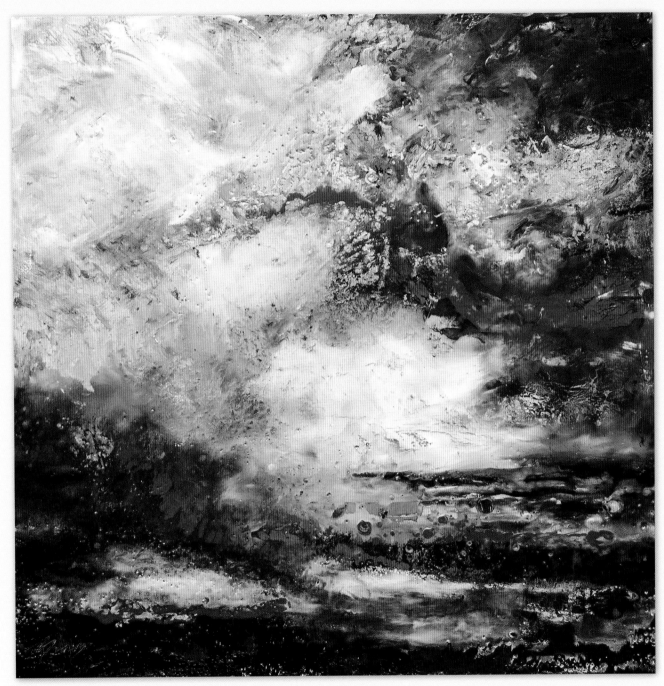

Aeon (Return)

Encaustic and gold leaf on wood, 15.94" × 15.94" (40.5 × 40.5 cm)

The red areas were painted with encaustic and oil pastel. The outbreaks of paint and the pearl-forming fusing process underline the uncontrollable character of the tornado as it rolls forward. The white areas were created using oil paint, which I rubbed on with my fingers.

Monotype in Encaustic

Introduction

Monotype is a printing technique that was already invented in the seventeenth century. Instead of painting on paper or canvas, you take metal, glass, or acrylic panels on which you draw or paint the design/picture. As long as the paint is wet, this design or picture can then be printed on paper by using a press or by rubbing over it by hand.

In encaustic work, monotype is a very comprehensive, self-contained technique. Therefore, I can only give a brief introduction here. You can begin with a simple stainless steel warming tray (for dishes). To achieve uniform and professional results, the printing plate should be an anodized aluminum plate, as it is less easily damaged by scratches, it provides an excellent, smooth printing surface, and the pigments do not react with the metal, i.e., the colors do not change. The heat level should be kept constant between 158° F and 203° F (70° C and 95° C).

The paper you select has a significant impact on the print image you create. An absorbent, thin paper, such as handmade Japanese kozo paper or Japanese tissue paper, absorbs the paint quickly, and the paint shows through on the back of the paper. This is desirable if you want to create a background, for example. That is, you are printing on the paper from both sides.

If you select a paper that is impermeable, such as marker paper or illustration paper, the prints are sharper and better defined, and the paint tends to remain on the surface and does not penetrate through to the back side. I use a *baren,* a disk-like hand tool with a flat bottom that is used in Japanese woodblock printing. You should protect your baren with aluminum foil, so that no wax stays stuck to it. You can keep replacing the foil.

It is best to use an infrared thermometer to check if the aluminum plate is at the right temperature. The higher the temperature, the more fluid the wax and the less accurate the resulting prints. If the encaustic paint is too cold, the paint will not be completely transferred onto the paper.

Do not lean over the aluminum plate, or you will inhale the fumes. It is very important to work in a well-ventilated room, or wear a filter mask if necessary. Clean the plate with beeswax and a lint-free cloth, and finally with water, to eliminate paint residues.

A Japanese *baren*, a disk-like tool with a flat bottom, wrapped with aluminum foil.

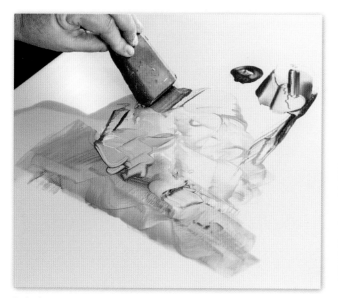

Painting on the heated aluminum plate.

The cakes of encaustic paint melt on the surface.

Print Imaging

When working with monotype in encaustic, you use a heated anodized aluminum plate, on which the design/picture is painted using cakes of encaustic paint. The cakes of paint melt on contact with the hot metal plate and remain liquid.

To print, lay your selected paper on it, "good side" down, then an absorbent piece of sketching paper or waste paper, that absorbs the excess wax that penetrates through. The picture from the metal plate is transferred to the paper by rubbing over it by hand with a baren. Now make a print.

Remove the sketching paper. Then carefully loosen the paper beneath at one corner of the plate, so that you then can lift and remove the print. Be sure you have clean

hands, or wear gloves. Any wax on your fingertips will leave wax stains on the paper. Work carefully both when laying down the paper, doing the hand printing, as well as when removing the print. If the paper slips, the print gets smudged.

When you are printing multiple designs on the same print, you need to make a marking (with tape) on the aluminum plate, so that you can always place the print exactly. In encaustic work, monotype quickly produces playful results. To create controlled results, however, it requires a lot of time and experience.

You can manipulate the paint on the plate to create patterns and lines. Brushes, erasers, palette knives, and old credit cards work well for doing this.

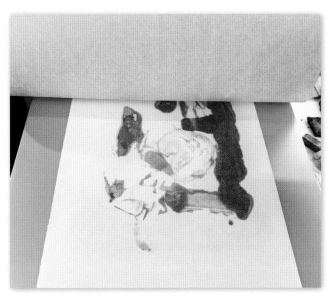

Place the paper on the design on the aluminum plate and then put a piece of absorbent sketch paper/waste paper on top.

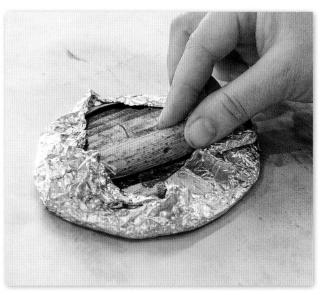

With a Japanese baren, use moderate pressure and rub over the entire surface.

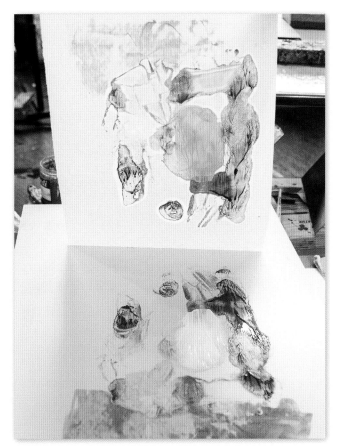

Carefully remove the print.

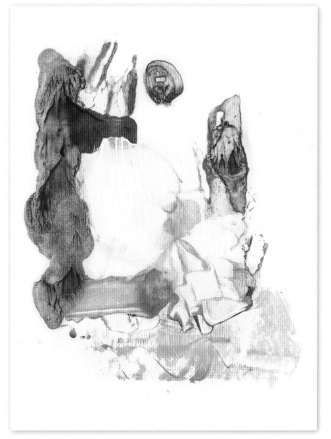

The finished test print.

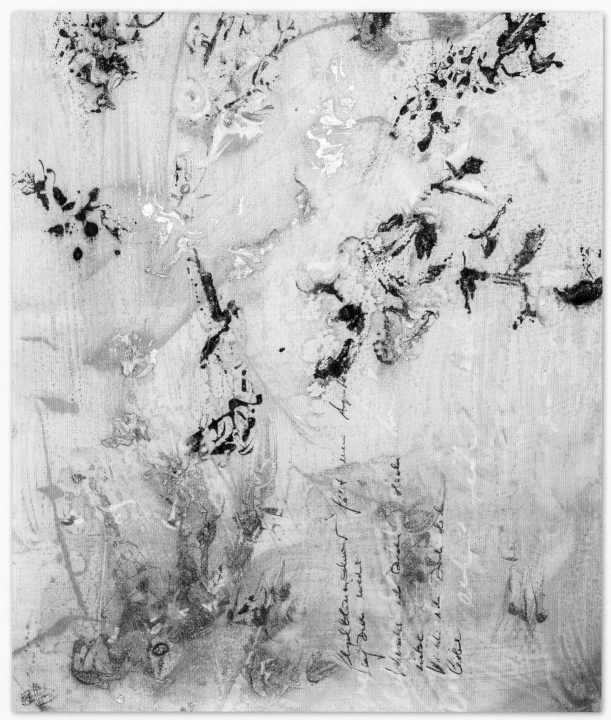

How Much I Love You, Though
Monotype in encaustic on kozo paper, 17.72" × 23.62" (45 × 60 cm)
For this print, I first printed the back side, so that the paint penetrated through and formed the background for the actual print. Then I printed the front side. Next I used a water-soluble graphite pencil to hand write the poem directly on the picture.

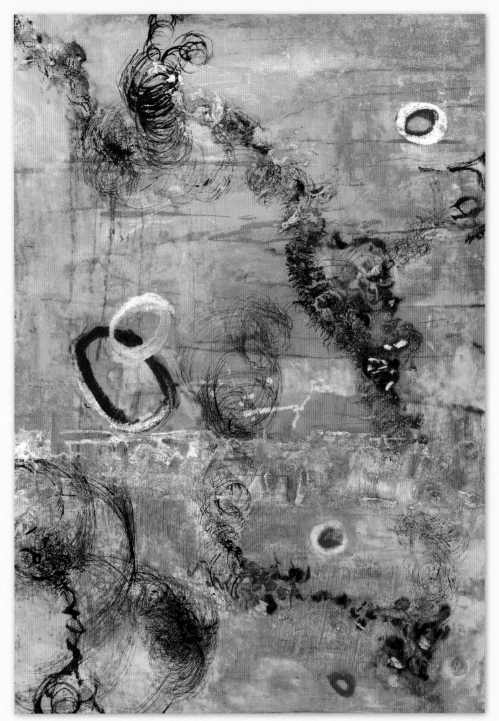

Tarantella

Monotype in encaustic on kozo paper, 11.81" × 19.69" (30 × 50 cm)
Here the background was first applied on the back of the print. The fine ink markings
were added using a silicone brush. The large circles were melted directly onto the paper,
on the hot aluminum plate.

Displaying and Care

Wax Drops

Because you are working with liquid wax, it will inevitably run down on the sides and form drops.

This can look very nice and emphasize the technique and medium. Unfortunately, it also leaves traces on the wall. Therefore, if you want to leave the drops of wax, I recommend that you use stick-on felt to raise up the wood support, so that it does not come into contact with the wall. Otherwise, you should carefully scrape off all the wax on the back of the wood support, so that the wax leaves no stains on the wall.

If you want a smooth wooden border, with no traces of wax, it is a good idea to carefully prepare the borders with masking tape before you begin to paint. This can then be easily removed later along with the wax drops.

Very often, the wax at the edge of the image, created by painting in layers, is damaged when the masking tape is peeled off. So you should be careful when pulling off the masking tape, and work cautiously.

Different side edges of encaustic pictures.

Wood substrate prepared with masking tape.

Wax Edges, Borders, and Frames

Because you are painting in layers, a wax edge is often built up at the edge of the picture, as already described. Wax edges emphasize the unique quality of the medium and are often a small work of art in themselves. You may choose to display the edges and wax drops on them without any concern. The frame protects both against damaging the edge and staining the wall.

However, in the everyday studio situation, they are predestined to get damaged, because they break easily when the picture is stored upright. One solution is to use a protective frame, which you can take off. If you opt for a clean border, then cut/scrape the lip away with a razor blade, a knife, or a pottery tool (modeling clay loop). You can also paint the sides of the wood support with wood or latex paint, or use encaustic paint.

Encaustic paintings look wonderful in shadow box frames. With these, you can keep wax textures and drops on the edges without worries. The frame protects against damaging the edges and the front surface.

Cut away wax edge with painted border.

Wax edge.

Shadow box frame.

Polishing the Painting Surface

You can polish your picture surface to a shine using a lint-free cloth. This enhances the luminosity of the colors. The transparent layers especially benefit from polishing the wax layer and create the desired picture depth, because the light can illuminate the picture more easily.

To polish the picture surface, however, you need a solid support, such as a wooden board. You cannot polish encaustic pictures painted on canvas if they are not mounted. Microcrystalline encaustic paint is more adhesive and soft, and therefore does not lend itself well to being polished. The higher the proportion of damar resin in the encaustic medium, the higher the gloss.

It may take up to a year for the wax—and thus the encaustic picture—to harden. The unsaturated hydrocarbons in the beeswax crystallize on the surface and form a white film. Damar resin prevents this to a certain degree, but the addition of pigments can lead to renewed chemical reactions. Crystallization can be removed by polishing. After about a year, this process is then completed. However, variations in temperature can trigger it again. I polish my paintings before each exhibition, so that dust is also removed.

If your picture is very dirty, you can wash it off in lukewarm water. Then you can rub it dry and polish it.

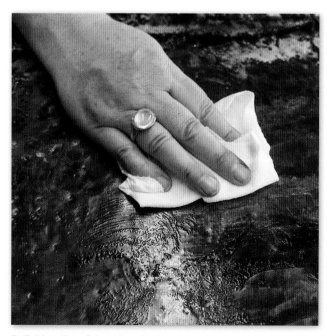

Polishing the picture to a luster.

Check to ensure every area has been polished.

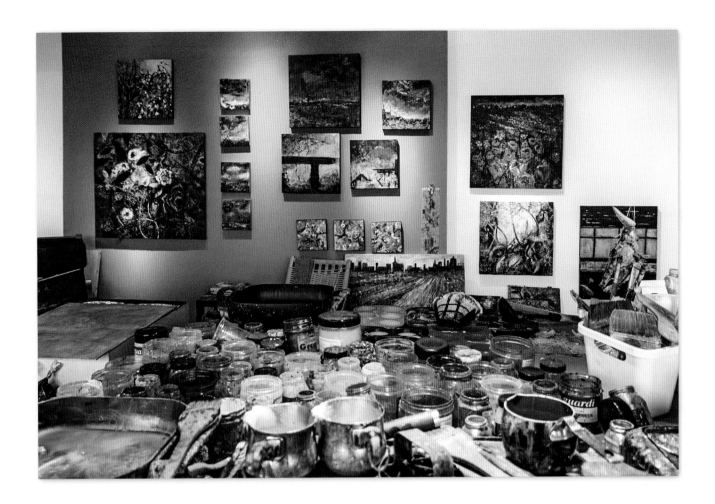

Storing and Transporting Encaustic Paintings

Room temperature is the most favorable temperature for storing the paintings.

If the temperature falls below 32° F (0° C), it can cause the wax to contract and to form fissures—the wax cracks. This may also be due to the quality of the wood panel, which can warp because of big temperature fluctuations, thus causing the wax layers to become detached. Warmer temperatures make the wax soft and dust particles stick to the wax.

Direct sunlight is undesirable because, as with oil paintings, the pigments are damaged by the UV radiation.

If a picture is exposed to the sun at a 90-degree angle over several hours, it can start to melt. The surface becomes very soft and vulnerable. (Do not leave your pictures in the trunk of your car, either in high summer or winter!)

If you transport or ship your picture, it is best to use some wax paper to cover the picture surface first and then use bubble wrap to wrap up the picture to protect it from damage.

Caution! The picture edges and corners are very easily damaged, so use an extra layer of bubble wrap on them!

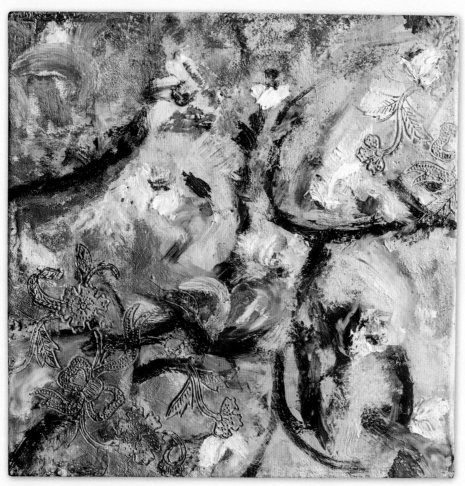
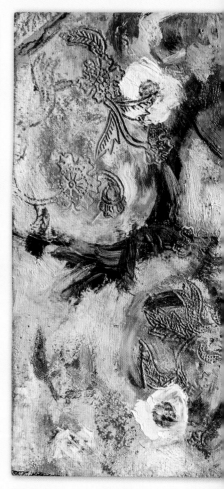

Covert Light

Triptych, encaustic on wood, 9.84" × 9.84" (25 × 75 cm)

Gold pigment was rubbed in and then fused into the relief imprints.

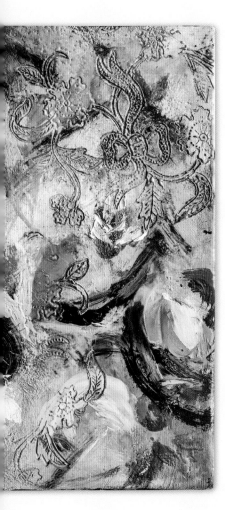

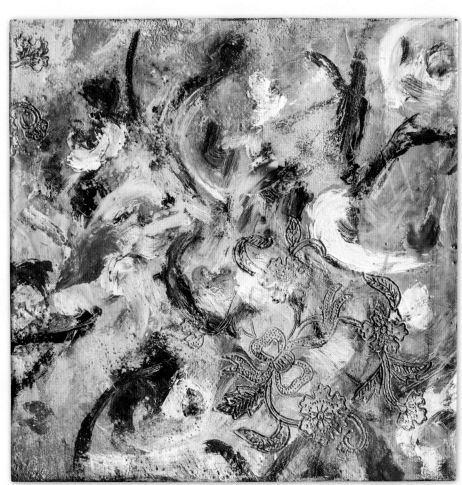

Gallery
Contemporary Encaustic in
Europe and North America

During a symposium in Carmel, California, Tony Scherman posed a question to the room: why would artists choose this primitive medium/painting method, of all things? Compared to wax, oil, for example, is a wonderful medium; encaustic, on the other hand, is not easy to handle and master.

It's likely that each artist would answer this question differently for themselves; what is common to everyone, however, is that they follow a specific purpose in their creation of images, and are simply fascinated by this ancient medium. The physicality, the transparency of the colors in relation to their opacity, the color intensity, luminosity, depth effect, and finally the three-dimensionality achieved in the presentation, are reasons often cited for using encaustic painting. Its cultural history and durability are further arguments for wax's unique quality as a medium.

For this gallery of contemporary encaustic art, I selected various artists from Europe and North America, all of whom I value very highly. Some have been working with the medium of wax for more than twenty years; they are pioneers and developed their own techniques, which serve their respective pictorial languages.

It is my great pleasure and honor to be able to show European and North American artists side by side for the first time. I am deeply grateful to all of them for saying "yes" spontaneously and without reservation, and making their images available to me to support this project.

Many much-appreciated colleagues are not included here because the number of pages in this book is, unfortunately, limited. This marks a start, though, and maybe I have a new, exciting project ahead of me.

Virgin (Jungfrau)
Encaustic on wood, 15.94" × 15.94" (40.5 × 40.5 cm)

Robin Denevan

Robin Denevan grew up in San Jose, California. In 1997, he received his BFA with distinction from the California College of Arts. Since the age of twenty-five, he has worked as a freelance artist.

Over the past twelve years he has participated in numerous national and international exhibitions. He is represented in many private collections. Robin Denevan lives and works in San Francisco.

Amazon Horizon
Encaustic on wood, approx. 60.43" × 60.43" (153.5 × 153.5 cm)

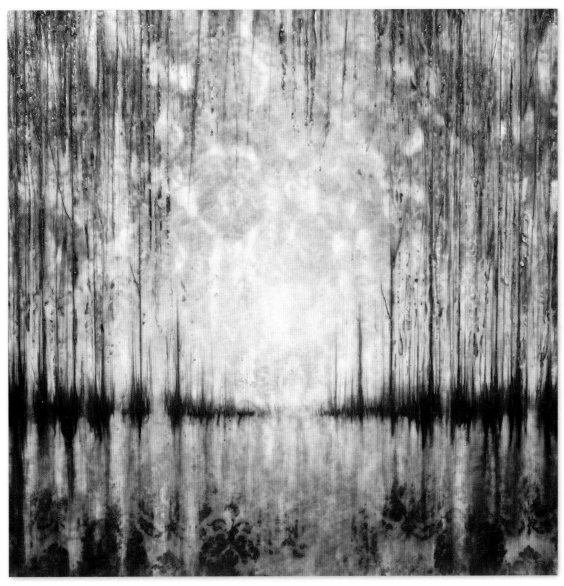

Reflections
Encaustic on wood, approx. 29.92" × 29.92" (76 × 76 cm)

Betsy Eby

Betsy Eby was born in 1967 in Seaside, Oregon. In 1990, she earned her BA in art history from the University of Oregon. Beginning in 1996, she has exhibited in numerous solo and group exhibitions in the US.

In addition to those in many collections and permanent exhibitions in the US, her works can also be seen in the permanent collections of the American embassies of Dubai, Brunei, and Gambia.

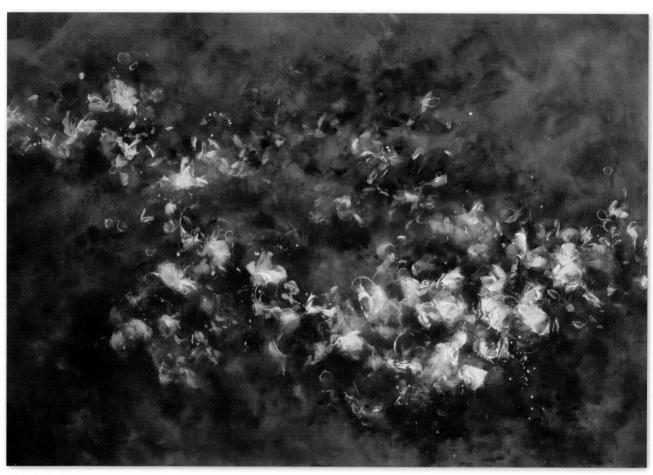

Third Variation on Scriabin's Mystic Chord
Encaustic on canvas on wood, approx. 55.12" × 79.92" (140 × 203 cm)

A Thousand Kisses Deep
Encaustic on canvas on wood, approx. 55.12" × 87.99" (140 × 223.5 cm)

Jennie Frederick

Jennie Frederick, born in 1951 in Kansas City, Missouri, received her BFA from the Kansas City Art Institute and her MFA from Indiana State University. She founded Kansas City Paperwork, Inc., in 1983, and has taught at the Kansas City Art Institute and held many private workshops. Jennie Frederick has participated in numerous international exhibitions. She lives and works in Kansas City.

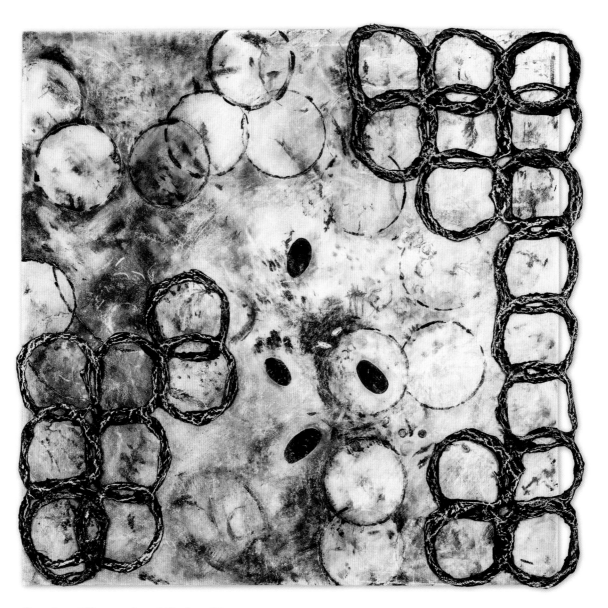

Construct/Deconstruct Series #2
Monotype in encaustic, ink and kozo (mulberry wood fibers), approx. 30" × 30" (76.2 × 76.2 cm)

Construct/Deconstruct Series #3
Encaustic and kozo (mulberry wood fibers), approx. 30" × 30" (76.2 × 76.2 cm)

Alexandre Masino

Alexandre Masino, born in 1972 in Montreal, Canada, received his BFA in 1996 from Concordia University. In the past twenty years his works have been shown in more than fifty solo and group exhibitions in Canada, the US, and Europe. His works are included in public and private collections in Canada, the US, and Europe.

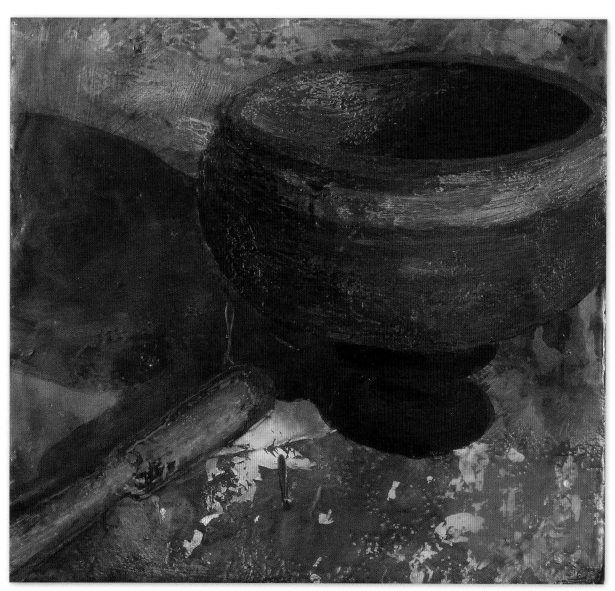

Odyssée
Encaustic and gold leaf on wood, 11.02" × 12.01" (28 × 30.5 cm). 2014.

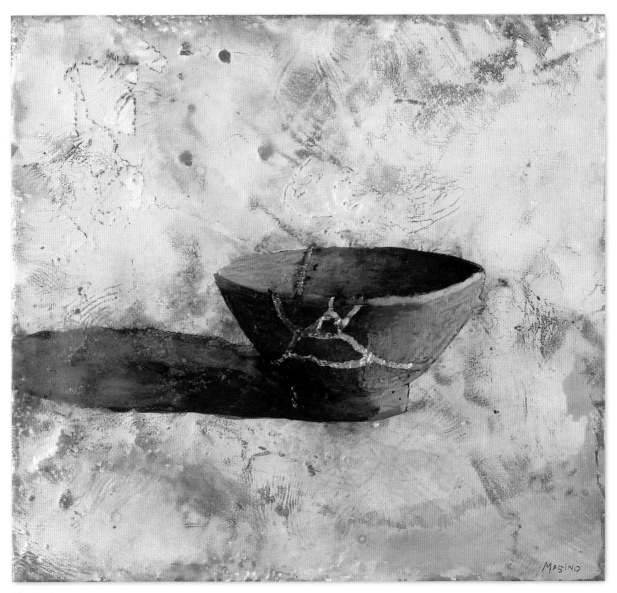

Kintsukuro
Encaustic and gold leaf on wood, 11.02" × 12.01" (28 × 30.5 cm). 2014.

Lora Murphy

Lora Murphy, born in 1965 in Dublin, Ireland, received her BA in 1983 from UCD Dublin. She has studied at the Art Students League of New York, at the Crawford College of Art and Design in Cork, Ireland, and at the Angel Academy of Art in Florence, Italy. She has had numerous exhibitions in Europe and the US. She lives and works in Ireland and Denmark.

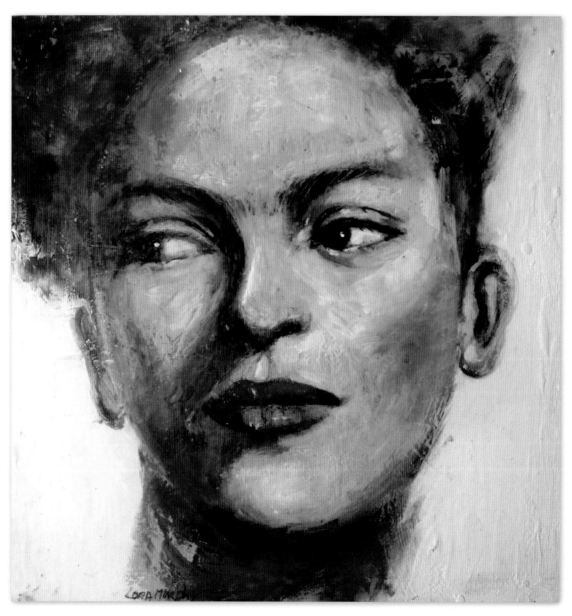

Frida
Encaustic on wood, 9.84" × 9.84" (25 × 25 cm)

Klaus-Ulfert Rieger

Klaus-Ulfert Rieger, born in 1927 in Wilhelmshaven, Germany, began to paint in encaustic thirty years ago. He is self-taught. His professional background in the dental technology industry enabled him to develop many special devices for his encaustic painting.

He has traveled to the US, England, and Holland to hold exchanges with other artists and restorers on encaustic painting. He is very private about his painting. He has rarely participated in exhibitions.

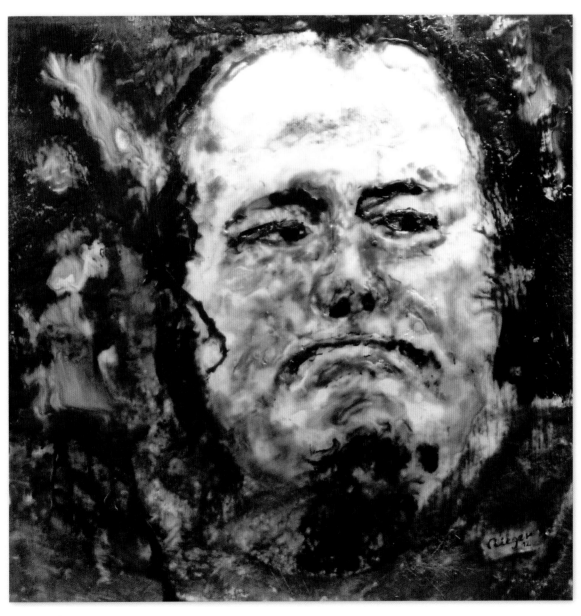

Steinbrück
Encaustic on wood, 19.69" × 19.69" (50 × 50 cm)

Paula Roland

Paula Roland, born in 1958 in Mississippi, received her BFA from Dominican College and her MA from the University of New Orleans. Since 1998, she has lived in Santa Fe, New Mexico. Paula Roland has presented her works in numerous solo and group exhibitions in the US and in Europe. She is a sought-after lecturer and developed the HOTBOX, which is used for encaustic monotype.

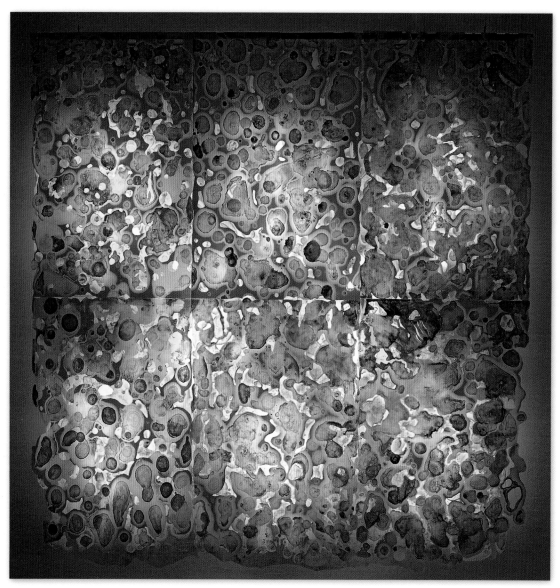

Disappear
Twelve illuminated encaustic monotypes (two layers) on Rives Lightweight paper, approx. 77.95" × 79.92" (198 × 203 cm). 2009.

Coral
Encaustic on wood, approx. 27.95" × 27.95" (71 × 71 cm)

119

Tony Scherman

Tony Scherman, born in 1950 in Toronto, Canada, received his BFA in 1971 from the Byam Shaw School of Art in London, England, and received his Masters of Fine Art in 1974 from the Royal College of Art in London, England. He has presented his works in solo and group exhibitions in North America and in Europe. He is an art critic and guest lecturer at universities and art schools in North America and Europe.

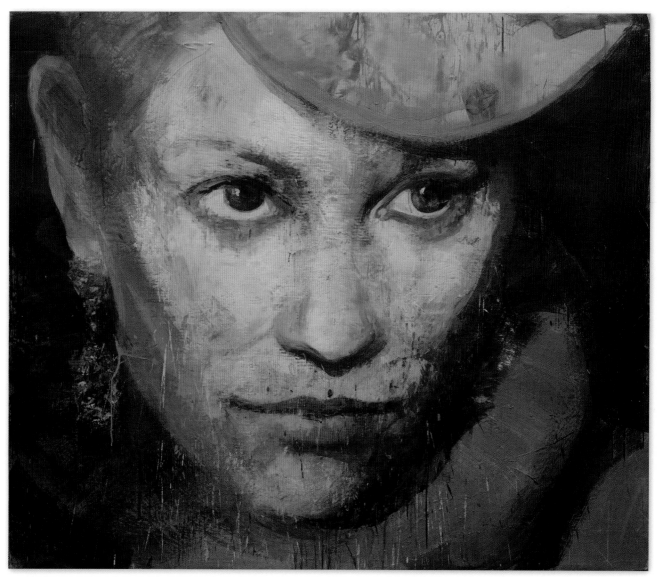

Difficult Women, Glenda Jackson as Elizabeth I
Encaustic on canvas, approx. 59.84" × 71.65" (152 × 182 cm)

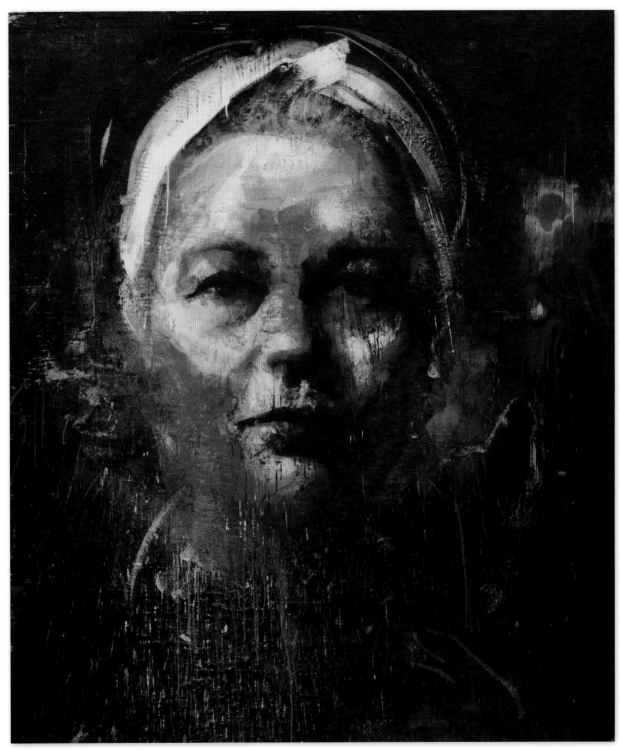

Difficult Women, Simone de Beauvoir
Encaustic on canvas, approx. 83.86" × 71.65" (213 × 182 cm). 2012–2014.

Yasemin Skrezka

German artist Yasemin Skrezka, born in 1961 in Berlin, spent her early years in Turkey then moved to Canada when she was six years old. She completed her BSc in physical therapy at the University of Manitoba, Winnipeg.

In 1983, she moved to Germany and graduated from Philipps University, Marburg, with a degree in motology. Since 2004, she has been a self-taught painter. Yasemin Skrezka has participated in numerous exhibitions in Europe.

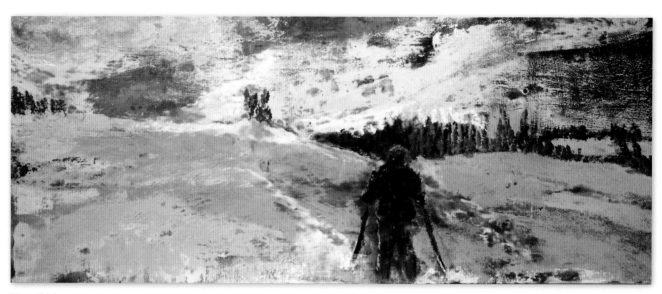

The Skier
Encaustic on wood, 15.75" × 39.37" (40 × 100 cm)

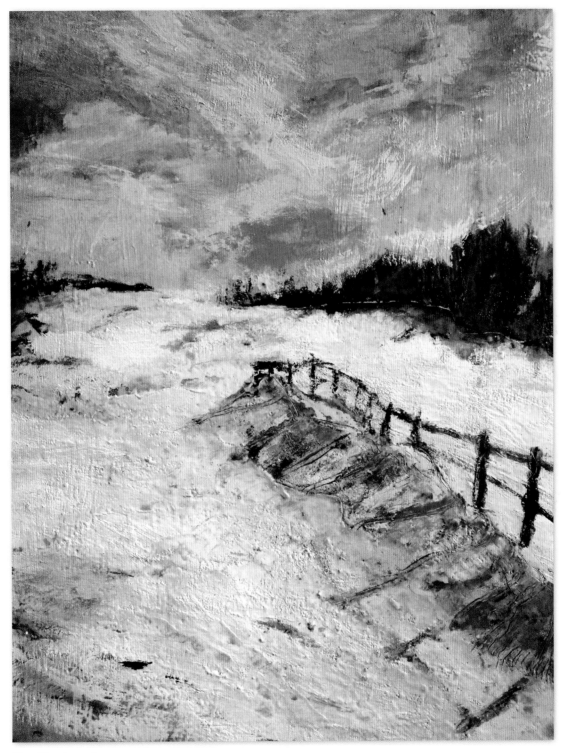

The Backyard
Encaustic on wood, 39.37" × 31.5" (100 × 80 cm)

Georg Weise

Georg Weise, a German artist, was born in Berlin in 1973, grew up in Mecklenburg, and studied in Berlin-Weissensee.

He has participated in seventy group exhibitions nationally and internationally, including twenty solo exhibitions, most recently at the Museum Junge Kunst, Frankfurt/Oder.

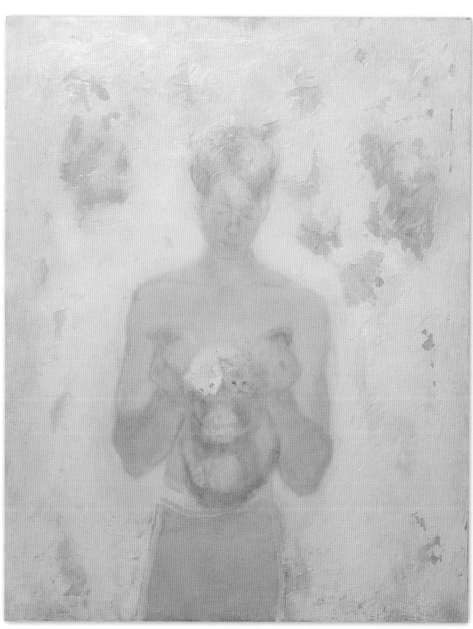

Katzenmörder [Cat Killer] (Matti)
Encaustic, 39.37" × 31.5" (100 × 80 cm)

Genaro
Encaustic, 70.87" × 55.12" (180 × 140 cm)

Glossary

Accretion: the building up of wax. Wax cools very quickly and therefore can be rapidly built up (accretion) by repeated brushstrokes.

Beeswax (filtered): beeswax that is purified by carbon filtering. It is a whitish semi-transparent color, and (at pharmaceutical grade) the preferred wax for encaustic work.

Beeswax (natural): the product of young honeybees, it has small semitransparent wax scales, and a low melting point.

Candelilla wax: a wax derived from the *Candelilla antisyphilitica* bush. It can be added to beeswax as a hardening substance.

Carnauba wax: this wax is obtained from the palm leaves of the carnauba palm, *Copernicia cerifera*. It can be added to beeswax as a hardening substance.

Cavo rilievo technique: relief imprint; this technique takes advantage of the moldable properties of wax. Objects are pressed into the wax and removed again.

Damar resin crystals: damar resin is obtained from a Southeast Asian tree. It is admixed with beeswax. A ratio of 1:8 produces a medium.

Damar resin varnish: contains turpentine and is not used in encaustic, since it is highly toxic when heated.

Encaustic: painting technique with ancient origins. It uses beeswax, pigments, and heat.

Encaustic gesso: special gesso for encaustic, containing less binder. It is more absorbent than conventional acrylic gesso.

Encaustic medium: binder for the pigments. It is often beeswax and damar resin crystals.

Encaustic paint: encaustic medium and pigments.

Engraving: carving into the surface with a sharp object.

Fusing: in encaustic work, the wax layers are fused together by using a hot air gun, a propane torch, or an iron.

Hot plate: a warming tray, which serves as a heated palette.

Hot spots: caused in wax by overheating; the wax floats to the side.

Image transfer: transfer of a picture or a photocopy to another surface.

Impasto: viscous paint application, mostly done with a palette knife.

Inlay: engraving a desired line or shape into the wax surface, then filling it in with another encaustic paint.

Intaglio: in encaustic work, carvings and engravings can be accentuated by filling them lightly with paint. Oil paint or oil sticks work well for this, rubbed into the lines.

Medium: binder for the pigments. It is often beeswax and damar resin crystals.

Melting point: temperature at which a substance is transformed from the solid to the liquid state.

Microcrystalline waxes: these belong to the group of microwaxes that are refined from petroleum. Microcrystalline waxes have significantly higher plasticity and stickiness compared to beeswax and paraffin waxes. Artists use these properties to paint on flexible supports such as canvas.

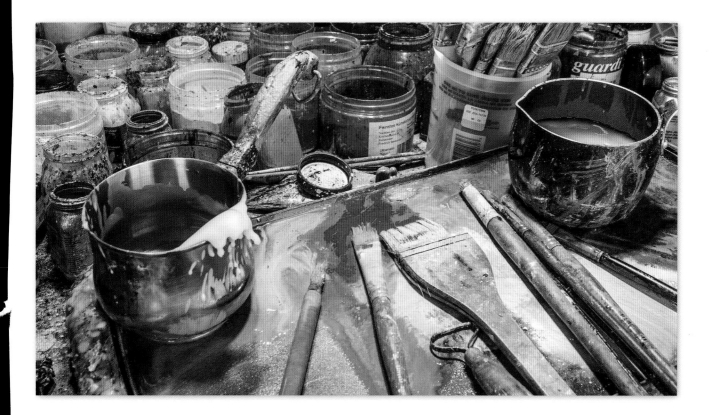

Monotype in encaustic: a printing technique invented in the seventeenth century. In encaustic work, a heated aluminum plate is used, on which the design/painting is drawn or painted. As long as the color is liquid/hot, you can print this on paper by hand rubbing.

Opaque: not light-permeable.

Painting iron: a type of iron used for fusing the encaustic layers.

Painting substrate: the surface on which to paint. Wood panels and wood are typical for encaustic work.

Paraffin: paraffin is one of the microcrystalline waxes that are refined from petroleum. Many artists pour paraffin onto a picture because it is clear and transparent, though extremely brittle.

Pigments: finely powdered coloring substances that are insoluble in the application medium (in contrast to colorants).

Prepared ground: the first layers of a picture; encaustic medium or encaustic gesso can be used.

Sgraffito: from the Italian *sgraffiare* (to scratch), a technique of layering and scraping a surface to expose the underlying layers.

Soy wax: soy wax has a very low melting point, so is of only limited use in encaustic painting, but is often used for cleaning brushes.

Translucent: light-permeable.

Wax: a natural material that can be made from animal, vegetable, or mineral substances.

Afterword

Learning something new means courage, and it also means not being afraid to make mistakes and fail. You need enthusiasm and curiosity to be able to do this.

Writing a book was a new experience for me, and on the way to the finished book I discovered and learned many new things.

Not only how to write and conceptualize a book, but also new techniques that I am now applying more and more in my pictures, such as the accretion method for wax.

On a journey into the unknown like this, having a network of positive people is a huge advantage. I want to give my thanks to my great love, my husband Maik, who always offers me unlimited support, covering my back, and believing in me and my art. And thank you to my children, who often make me laugh and give me gifts of hugs, even when I'm stressed.

My thanks also to my parents, who likewise believed in my book. Especially my father, who, even when he was suffering from cancer, still assured me in the last week of his life, that he would like to promote the book on the Internet.

My especial thanks go to Britta Sopp from Christophorus Verlag. She shared my vision and supported me and my ideas for the book design from the start. Like a good fairy, she pulled the strings and made this project possible in a miraculous way, almost at the speed of light.

A big thanks also to my son Philip, who took the beautiful photographs of the studio and techniques (thank you for your angelic patience, with over 1,600 photos!).

Thanks also to Darin Seim of R&F Handmade Paints, who connected me with the Art Select Company and Ms. Sopp, and so shared significantly in the realization of the book.

Special thanks to graphic designer Michael Feuerer, whose sharp eyes discovered the smallest blur in the pictures and, with a lot of patience and positive criticism, made the case for better quality photos, so that I drove through ice and snow to my studio to take up the fight with the tripod again.

Thanks to you, dear readers. I want to encourage you to take yourself on the encaustic journey, perhaps to attend a course, and paint for many hours.

You will gain valuable experience not at the final goal, but along the way!

Warm greetings from wintry Detroit,
Birgit Hüttemann-Holz